D1064690

NOT ADDED BY
UNIVERSITY OF MICHIGAN LIBRARY

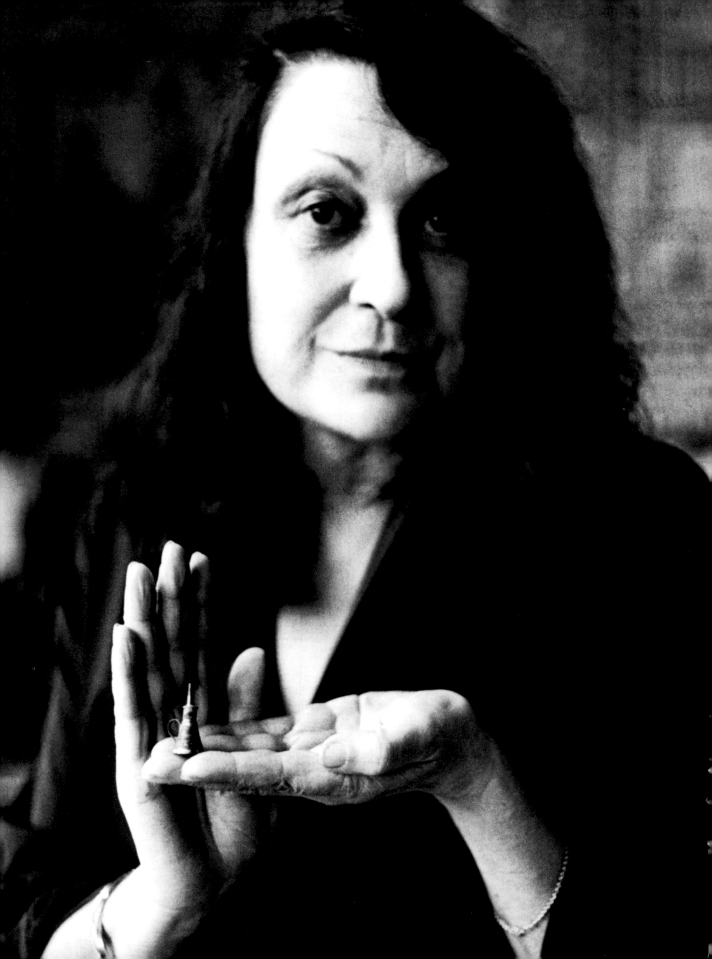

Lina Bo Bardi, Drawings

Zeuler R. M. de A. Lima

Princeton University Press

Princeton and Oxford

In association with Fundació Joan Miró

Barcelona

INSTITUTO BARDI
CASA DE VIDRO

Images copyright © 2019 by Instituto Lina Bo e P. M. Bardi
Text copyright © 2019 by Zeuler R. M. de A. Lima

Requests for permission to reproduce material from this work should be sent to Permissions, Princeton University Press
Published by Princeton University Press, 41 William Street, Princeton, New Jersey 08540
In the United Kingdom: Princeton University Press, 6 Oxford Street, Woodstock, Oxfordshire OX20 1TR

press.princeton.edu

Frontispiece and back cover: Lina Bo Bardi. Photo: Bob Wolfenson, 1972. ILBPMB Archives.
Front cover: Lina Bo, Study for exhibition at Milan Triennale Pavilion (*detail*), ca. 1946.
Watercolor, gouache, pencil, and India ink on cardboard, 31.4 × 43.3 cm, ILBPMB Archives.

All Rights Reserved

ISBN 978-0-691-19119-5

LCCN: 2018960812

British Library Cataloging-in-Publication Data is available

Designed by Ken Botnick

This book has been composed in Lyon and Balto typefaces

Printed on acid-free paper. ∞

Printed in China

10 9 8 7 6 5 4 3 2 1

Contents

Director's Foreword

It is an honor for the Fundació Joan Miró to present *Lina Bo Bardi, Drawings*, an exhibition that offers insight into the legacy of the Italian-born Brazilian architect through a series of drawings carefully selected by Zeuler R. M. de A. Lima.

Miró and Bo Bardi shared a particular view of drawing as a guide and a prolific everyday practice that spanned their entire lifetimes. Today, we understand that Bo Bardi contributed to opening up the monolithic approach of modern architecture and is an essential figure for understanding the evolution of the modern movement from a female and rather unorthodox perspective. The multifaceted flexibility of her work is undoubtedly the underlying key to her extraordinary relevance to this day.

Another point in common between Miró and Bo Bardi is their admiration of Antoni Gaudí. In Gaudí's architecture, Joan Miró recognized constant experimentation, an urge to challenge the medium and push its boundaries, and the coexistence of tradition and modernity. Bo Bardi visited Barcelona with her husband in 1956, and her appreciation of Gaudí's work became a reference of *genius loci* for the Italian-Brazilian architect.

Last, the two shared the advocacy of free, genuine thinking through the making of art, hence our pleasure at being able to show the drawings of Bo Bardi in the Fundació's galleries. We wish to thank curator Zeuler R. M. de A. Lima for his impassioned and thorough research and for his generosity in carrying out this project. We are also most grateful to the Instituto Lina Bo e P. M. Bardi for loaning the pieces, and for the involvement of its members Waldick Jatobá, and Anna Carboncini. We wish to thank the staff at Princeton University Press as well, and especially Michelle Komie, for their efforts in making this book possible.

Marko Daniel
Director of the Fundació Joan Miró

Lina Bo Bardi, Drawings

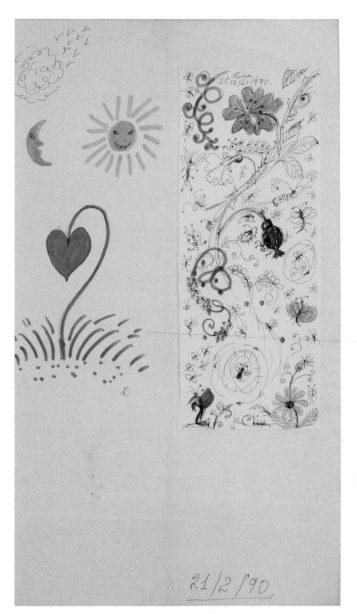

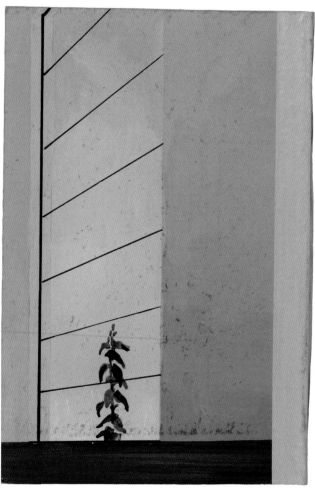

1 Lina Bo Bardi, Card drawn for Pietro Maria Bardi, 1990. Ballpoint pen, felt pen on paper, 35.4 × 21.6 cm, ILBPMB Archives.

2 Lina Bo Bardi, Plant at windowsill likely painted during the lyceum of the arts program in the early 1930s. No date. Gouache on card stock, 15.6 × 10.6 cm, ILBPMB Archives.

Prologue

In early 1990, at the end of her life, Lina Bo Bardi produced a small, colorful drawing of vines with flowers, butterflies, bees, beetles, and other insects (Fig. 1). Three days later, she folded the drawing to form a card and added another drawing on the left side of the spread.

She was seventy-five years old and had mastered graphic conventions, yet her drawing had the lighthearted shapes and colors of the ones she made as a child. As her sight diminished, her writing became larger, and as her joints stiffened, she struggled to hold pens and brushes, making her drawings uneven, economic, and expressive. Still, neither debilitation limited her imagination. At the center of the folded card she sketched a red heart-shaped flower and added above it a blue crescent moon and a yellow sun. On the cover, she wrote "To Pietro, Lina," in playful, ornate letters.[1]

Despite the physical hardships of aging, Bo Bardi had complete command over the intent, gesture, and effect of the marks she put on paper, the kind of control she started to hone in her artistic education in Rome in the early 1930s before studying architecture.

During that formative period, she produced a carefully drawn study of an upright plant in a flowerpot, standing against an oversized window as it looks for light (Fig. 2). This image—like the vines in her card to Pietro, her husband—is simple, yet full of affect. Constructed around a distant and low vanishing point, it shows her skills in Renaissance perspective, enhancing the classic grandiosity of the architecture that was becoming common in Italy at the time. Simultaneously, the image is immersed in the atmosphere of modernist metaphysical painting. This framing—whether intentional or a copy—reveals an awareness of the cultural and artistic values around her, her introspective personality, and her audacity.

In both drawings, single-stemmed plants stand alone and determined, as Bo Bardi often did throughout her life. Through drawings, she expressed, in silence, what she could not articulate with words.

Drawing Constellations

This book is about the love architect Lina Bo Bardi (1914–1992) had for drawing. It is about the profound sense of connection, discovery, and invention that she developed by making marks on paper, beginning during her childhood in Rome and lasting until her death in São Paulo. Drawings were, for her, more than a collection of graphic signs. Drawing was her most powerful means of creation and her primary language of communication. Drawing, with its slow and intimate gestures, was her way of dwelling in the world. She changed her way of drawing as she moved in and out of different practices and places. Drawing was one of her solitary anchors in a constantly transforming existence.

Over the span of her life, Bo Bardi produced more than six thousand drawings and graphic notes and collected them in her personal archives, most of which are currently kept in the house she designed for herself and her husband in São Paulo. Although she wrote extensively throughout her life, she left very few notes or comments about the motivations behind her drawings and sketches. She rarely verbalized their meanings either, though they are powerfully evocative. She used drawings to express emotions, to think, to resolve problems, to conceive of a cultural project. As such and though they evolved chronologically, their production does not fit a linear process.

With few exceptions, they were not intended to be pieces with independent aesthetic purpose. Her drawings are not isolated events. They exist in a range of relationships, scales, visual patterns, themes, and desires.

Many of Lina Bo Bardi's drawings have now been made public through the digitalization of her archives and publications and exhibitions celebrating and analyzing her work. Such visibility has helped grant her well-deserved international acclaim as one of the prominent architects in the twentieth century, known for her work as a designer, editor, curator, and public intellectual. However, her remarkable drawings, unique when compared to those of her contemporaries, have remained marginal to the understanding of her personal and professional development.

Bo Bardi was educated in the *disegno* conventions of Italian art both in the lyceum for the arts and in the school of architecture in Rome during the increase in popularity of Mussolini's regime. Surrounded by the classical and baroque

traditions of Rome, she learned how to fine-tune her vision, building and composing images according to principles of realist representation without abandoning the intuitive freedom of her childhood watercolors. Her early professional experience as an illustrator and editor in Milan during World War II opened her eyes to the exacting order, thin lines, and blank spaces of rationalist design.

The emergence of neorealist sensibilities in Italy at the end of the conflict offered fertile ground to combine the magical imagination of Bo Bardi's early years, the classical principles of her education, and the rationalist economy of her editorial practice. Her move to Brazil in 1946 and the encounter with new formal and informal artistic developments allowed her to produce drawings with themes, forms, and colors that matured her understanding of reality and her desire to transform it as an architect. The oscillation between academic and modern values expressed in her drawings is seen throughout her life and career as she reconciled the traditions of *disegno* with her desire for innovation.

Bo Bardi devoted her career to understanding how the work of design can be connected to practices of everyday life, a belief that stemmed from of her personal experiences growing up and living through challenging political times. It may not be a coincidence that the first drawings that remain from her youth are placid scenes of trees, rural landscapes, and festive crowds, themes that reappear in many of her mature works. In her view, simplification was the goal of design, and people, not designers, were the protagonists of architecture. She wanted her work to touch people's lives.

While Bo Bardi had a prolific career in architecture and furniture, graphic, stage, and exhibition design, little of her work was built or remains in use. The numerous drawings she produced are the most complete visual testimony to her design practice and to her vision of culture and society. Her production simultaneously subscribed to classical, rationalist, and picturesque values, enriched by a certain magical realism. Unlike most architects of her generation, she allowed herself great freedom in the exploration of contrasting themes and techniques in her work.

The one hundred works herein come exclusively from her archives. Culled from her childhood to her later years, they aim at presenting a genealogy of Bo Bardi's relationship with the medium, representing the personal and professional development of a unique designer and thinker whose career encompassed different methods and measures. They reveal both her personal skills and the changing aesthetic values and practices of the periods and places in which she lived.

Despite using drawing as a powerful creative, nonverbal means of communication, Bo Bardi never claimed her drawings were works of art. Still, she was in dialogue with her cultural and artistic surroundings and continuously transformed her method, generating new patterns related to her pursuit of old and new themes. Independent from the relentless modernist concern with universality and novelty, her drawing skills and repertoire moved freely between the values of academic figurative art and modern, abstract rationalism, and finally emancipated themselves in the rupture of boundaries between art and life proposed by contemporary art in her mature years.

This book honors the way Lina Bo Bardi looked at works of artistic creation. She saw them as documents of a process, rather than isolated, final objects. She was suspicious of conventional historical interpretations that place the scholar between the observer and the thing observed, keeping the viewer from having her or his own relationship with the work. She once wrote that history should not transform documents into monuments,[2] a principle she adhered to in the exhibitions and collections she organized throughout her lifetime.

This volume therefore includes, in equal terms, works ranging from fast sketches produced as design notes and carefully drafted and colored images, to childhood watercolors and personal notes using tools immediately available at her desk.

The present selection of drawings is organized analogously to the way Lina Bo Bardi displayed the permanent collection of the Museum of Art of São Paulo (MASP) in its open, glass hall that she designed in the 1960s. In that space, works of art from different origins and periods, by different artists and representing different themes and techniques, coexist in subtle visual patterns. Bo Bardi's intent was to introduce the works as if they had just been finished by their creators, still sitting on easels, free of walls and labels. At MASP, even the easels dematerialized into the transparency of the glass of which they were made. Visitors were invited to move through the exhibition, to slow down, and to inhabit the life of the works. And if factual and historical information about them was necessary, one could find it on the back side of the easel supports.

Like exhibitions at MASP, this book presents constellations of images organized according to interpretive and thematic lines. The initial sections offer a chronological understanding of her early emotional and artistic relationship with drawing, followed by the development of different techniques and themes during her education in Rome and her early career in Milan. The second part of the book

investigates how Bo Bardi transformed her Italian drawing experience in her encounter with Brazil, revisiting themes of her youth, maturing her approach to architecture as a stage for life, and letting go of some of the artistic conventions of her early education.

While proficiency in drawing has lost prominence in contemporary art in general, and in architectural practice in particular, Bo Bardi's drawings remain a fresh reminder of the continued importance and value of free, authentic thinking and of skillful, educated hands. To her, drawing was an act of love. She wanted to understand the world and how we inhabit it. Swaying, delicate lines and strong colors are present in the many drawings she produced in her youth. Later, as an architect, she used lines and bright hues to ascribe poetic meaning to small everyday details. Her gestures moved from one sheet of paper to another, from one idea to another, from one image to the next. They moved from her youth into her maturity. She wanted to circumscribe the gray tones of reality. She wanted to populate the world with the whole spectrum of colors.

A Life Worth Drawing

More than the design tool of an architect, to Lina Bo Bardi, drawing was a primary expressive means driven by the strong sense of curiosity and doubt she had nurtured since an early age. Many of the thousands of drawings she produced over six decades were explorative working drawings.[3] Most of them were small and simple. She used pencils, watercolor, gouache, felt pens, and ballpoint pens to produce works on tracing paper, newsprint, regular paper, and card stock. These tools formed part of the daily routine of her design practice, and often the drawings were not meant to last beyond her decision-making process.

Bo Bardi never claimed drawing to be an independent artistic language, but she embraced it with artistic purpose. Throughout her life and career, drawing had a prominent yet ambivalent role. It was a noun and a verb, outcome and process, object and relationship. On one of the few occasions when she wrote about drawing, she stated that drawing should be understood as Piero della Francesca understood it, that is, as *disegno*, or as he defined it, in "the profiles and contours that are contained in things."[4] This definition of drawing suggests the externalization of basic physical and visual features of particular objects. Simplicity and clarity were her goals.

Bo Bardi developed her love of drawing and artistic sensibility as a child; her father, Enrico Bo, an accomplished amateur painter of urban scenes, inspired by Italian metaphysical paintings, encouraged her. His use of drawing and his interest in painting were important points of connection between the two, and he helped his daughter develop basic technical skills. He taught her the principles of perspective, three-dimensional drawing, and the use of watercolor. Bo Bardi quickly learned from him how to draw steady lines and how to combine bright colors in an appealing manner. In the beginning, unlike her father, her theme of choice focused on semirural landscapes with lush vegetation and small houses (Figs. 3 and 4).

These early works suggest her premature observation of the struggles of life and death, as she had grown up between two world wars. They also suggest her pleasant memories of outings to the Abruzzo hills to visit her maternal grandfather, who took her out on short trips around the countryside. As a young inhabitant of a working-class neighborhood in Rome, her early interest in landscapes and trees foreshadowed her lifelong aspiration for an idyllic, simple life and the pursuit later in life of what she considered to be organic architecture.

Through drawing, Bo Bardi observed, imagined, and aspired to understand

and transform reality. She idealized a better world in which to live, for herself and others, and configured an unusual image of people's relationships to other people, to space, architecture and cities, to nature, and to everyday objects. She produced drawings and sketches that are of a type seldom associated with mainstream twentieth-century architects, commanding yet sometimes childlike in their simplicity and vibrancy. She pictured joy and humanity.

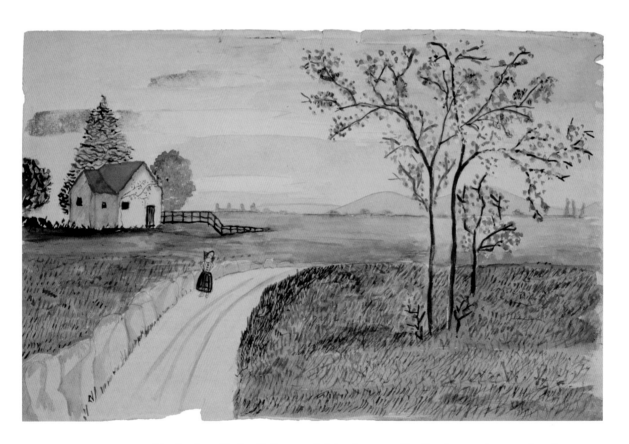

3 Lina Bo, One of Bo Bardi's first recorded drawings, 1925. Pencil and watercolor on card stock, 22.0 × 34.0 cm, ILBPMB Archives.

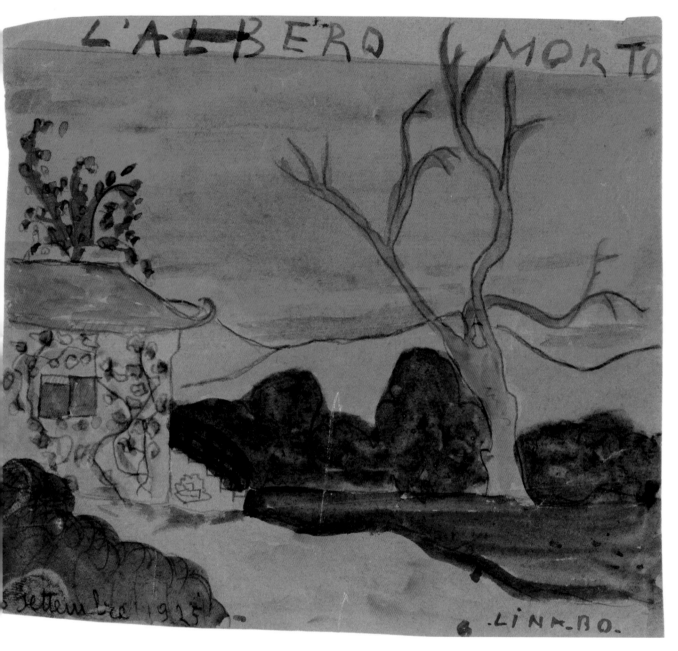

4 Lina Bo, "L'albero morto" (The dead tree), one of Bo Bardi's first recorded drawings, 1925. Pencil and watercolor on card stock, 10.8 × 12.0 cm, ILBPMB Archives.

Drawing the Stages of Life

The first documented drawings by young Lina are copies of bucolic compositions and illustrations, which evolved into elaborate images of urban scenes in her adolescence. As a child, she started to use simple, fast techniques with pencil, ink pen, and watercolor, which she never abandoned. Early evidence of her creative work between ages nine and eleven reveals her interest in representing three-dimensional space, expressed by using perspective and layered color planes in different saturations of hues.

During that period, Lina enjoyed copying illustrations that she found around her household and school. Once she entered the lyceum for the arts in Rome in 1929, she learned to produce observation drawings as a documentation technique. Until then, her father was her main supporter, teacher, and artistic mentor. Lina idolized her father, and as a child sometimes used his works as models for her own creations. He occasionally did the same with her watercolors.[5] Both corresponded through drawings even as adults after she moved to Brazil. She showed a liking for his oil paintings, especially those with the picturesque and imaginative atmosphere of urban scenes, and she reinterpreted his painting of a group of people eating watermelon around a table in the middle of "Piazza Guglielmo Pepe" into her "Summer watermelon," produced in 1929, showing a comparable scene from a lower perspective in watercolor (Fig. 6).

Her initial works show a controlled use of lines with a particular ability to draw in circular movements. Softening the sharp edges of solid elements along with the abundant use of color were techniques that she used throughout her development and carried into her professional work as a designer. Later in life, she would complain about how most architecture students "draw with threads when not in impressionistic *chiaroscuro*, which keeps us from fully understanding the profound essence of each form."[6] Her lines and marks, instead, were clear and confident.

The spaces she represented in the colorful pictures of her youth were meant to stage collective activity and human life, a theme that would inform her definition of architecture later in life (Figs. 5 and 7).

With few exceptions, buildings were not the emphasis of her early drawings. When she did represent architecture, the focus was on the public spaces it shaped rather than on the buildings themselves, such as the drawings she made of streets around Rome (Fig. 8). Her concern with the color and atmosphere of such images

expresses an affinity to her father's paintings and announces her interest in social gatherings and in the careful composition of urban scenes. These images show how Bo Bardi, in her maturity, saw architectural elements as configuring a stage for daily life.

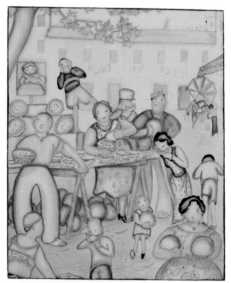
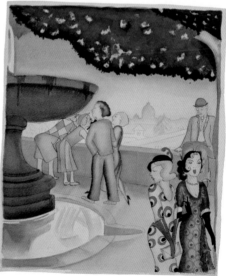

5 Lina Bo, "Alla Madonna del Divino Amore" (To the lady of divine love), interpretive copy, ca. 1930. Watercolor, gouache, and pencil on card stock, 29.8 × 25.7 cm, ILBPMB Archives.

6 Lina Bo, "Anguria di estate" (Summer watermelon), interpretive copy, ca. 1930. Watercolor, gouache, and pencil on card stock, 29.8 × 25.7 cm, ILBPMB Archives.

7 Lina Bo, "Trinità dei Monti" (To the lady of divine love), interpretive copy, ca. 1930. Watercolor, gouache, and pencil on card stock, 29.8 × 25.7 cm, ILBPMB Archives.

8 Lina Bo, Roman urban
scene, no date.
Watercolor, gouache,
and pencil on card
stock, 29.0 × 15.2 cm,
ILBPMB Archives.

Reasons to Draw and Withdraw

From an early age, Lina tended to isolate herself.[7] She treated her school environment with indifference and tended to spend much time alone. Still, her imagination blossomed, and she devoted extra time and work to her drawings.

Lina had good reason to feel alienated as a young woman in Italy in the 1920s. She grew up in a time of serious economic and political problems and in a culture in which opportunities for women were often limited, especially with the fascist bureaucracy placing the traditional model of the mother-woman—domestic and productive—against the modern woman—urbane and decadent.[8]

Although her uncle, Natale Alberto Simeoni, a bohemian, fascist journalist, introduced her to cultural experiences such as theater, cinema, and even burlesque comedy during her adolescence, she was not exposed to female artists.[9] In addition, her austere mother tried to reinforce conventional gender norms, which were incompatible with Lina's temperament. Coming of age under such circumstances was most certainly a handicap to a young woman with aspirations of independence.

Many of the compositions Lina produced in her adolescence are charged with contrasts—extremes of light and color, darkness and brightness, movement and serenity—and represent evocative themes that range from containment and desire to self-importance and abandonment. Like many of the illustrations she produced in her early professional life, these drawings may have derived from other sources, probably fairy-tale books or even magazines intended for female audiences.

She produced several drawings touching on what seem to be existential dilemmas of young women. The figures in those compositions—whether they were copies or creations of her own—appear in carefully studied poses. They resemble the affected yet introverted and self-conscious exacting poses in which Lina let herself be photographed as a child and later as an adult (Figs. 9, 10, and 11). A similar attitude of defiance is present in the self-portrait she made of herself sitting with her legs open, leaning against the back of a chair, a pose generally associated with men (Fig. 12). Although these drawings speak more of her internal world than her surroundings, they present the rich chromatic palette and romantic idealism that found their way to her mature works.

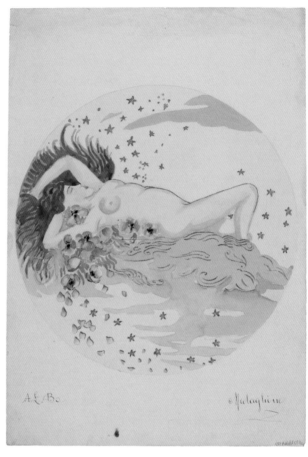

9 Lina Bo, No title, ca. 1927–28. Watercolor and pencil on card stock, 21.5 × 12.7 cm, ILBPMB Archives.

10 Lina Bo, "Medaglione" (Medallion), no date. Watercolor and pencil on card stock, 33.8 × 23.6 cm, ILBPMB Archives.

11 (*facing page*) Lina Bo, No title, ca. 1927–28. Watercolor and pencil on card stock, 15.9 × 10.7 cm, ILBPMB Archives.

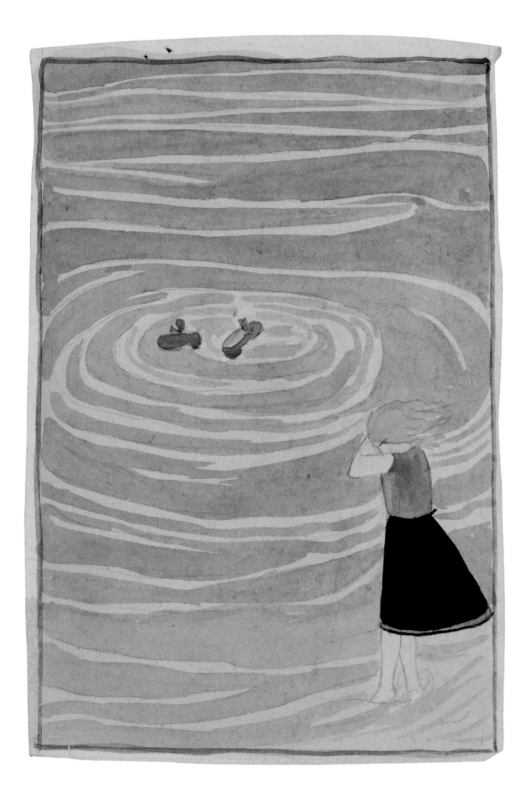

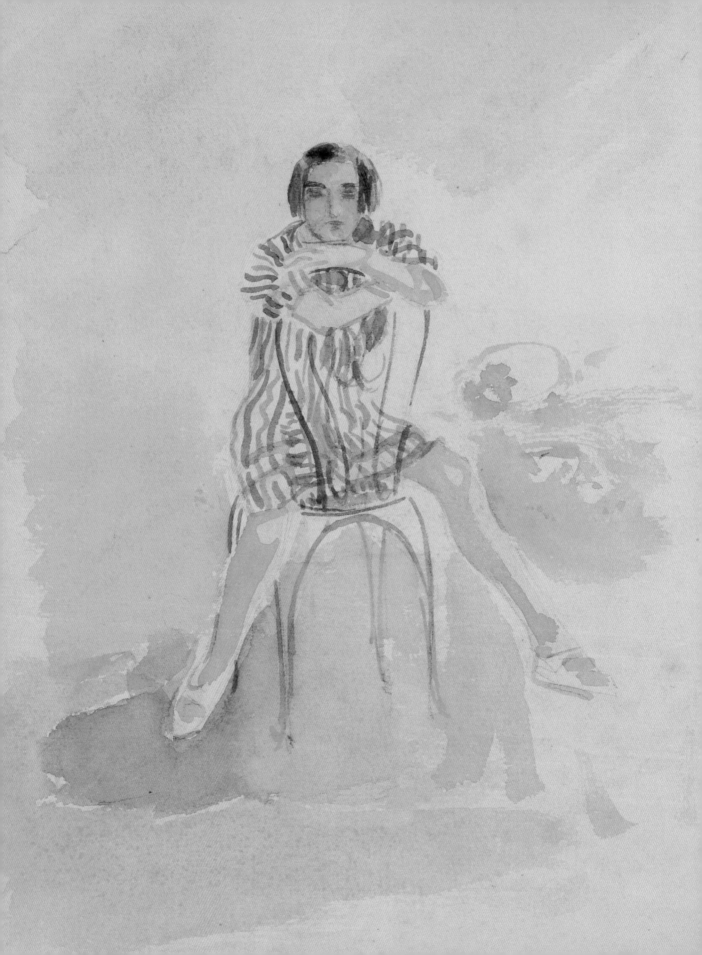

Drawn to Academic Conventions

The drama in Lina's drawings and in her early life increased in intensity as she moved into her secondary education. Since she had not excelled in the *esame di stato* (high school admission exam) after middle school,[10] she could not continue her schooling in a *liceo classico* (classics lyceum), the most competitive program in Italian high school instruction. As a consequence, a future career in sciences, literature, philosophy, or law was not available to her. Her best option was to attend the *liceo artistico* (lyceum for the arts), the school offering courses especially geared toward licensing teachers with theoretical and practical training in the visual fields.

Lina attended the Liceo Artistico di Roma from 1929 to 1934, between ages fifteen and nineteen. The school's curriculum was, according to her, "mainly dedicated to the preparation in arts and architecture, and included studying architectural canons from Vitruvius to Vignola, shadow theory and geometric drawing."[11] Given the prominence of Mussolini's regime and his desire to renovate the capital according to the glory of the old Empire, the Roman cultural establishment was strategically removed from the aspirations of European artistic avant-gardes. Even the intense promises of the Novecento movement had been kept at bay in the north of Italy. The Roman lyceum was therefore the artistic territory of classical values, exacting contours, symmetry, light and shadow, two-dimensional compositions, and one-point perspective.

She developed her representational techniques and understanding of traditional architectural principles during this period. She improved her drawing skills and learned academic conventions, producing and reproducing a series of refined figure drawings and portraits, mostly in graphite (Figs. 13 through 16). She incorporated the learned techniques of line contour, human figure, and *chiaroscuro* into new sketches, giving the colorful drama of her earlier female figures an atmosphere of black-and-white suspense (Fig. 18).

Lina also started to explore the simplification of forms. While her earlier figurative compositions of complex urban scenes used one-point perspective, she became fond of the organization of the visual field in two-dimensional stacked tiers as the background to central characters, a technique she would master in her editorial work later on (Fig. 17). She extended the effort of formal abstraction to a few experiments with human and organic shapes reduced to simple geometric and chromatic compositions (Figs. 19 and 20) and even to a simplified classicism that

12 Lina Bo, Self-portrait, 1933. Watercolor and pencil on card stock, 28.0 × 18.9 cm, ILBPMB Archives.

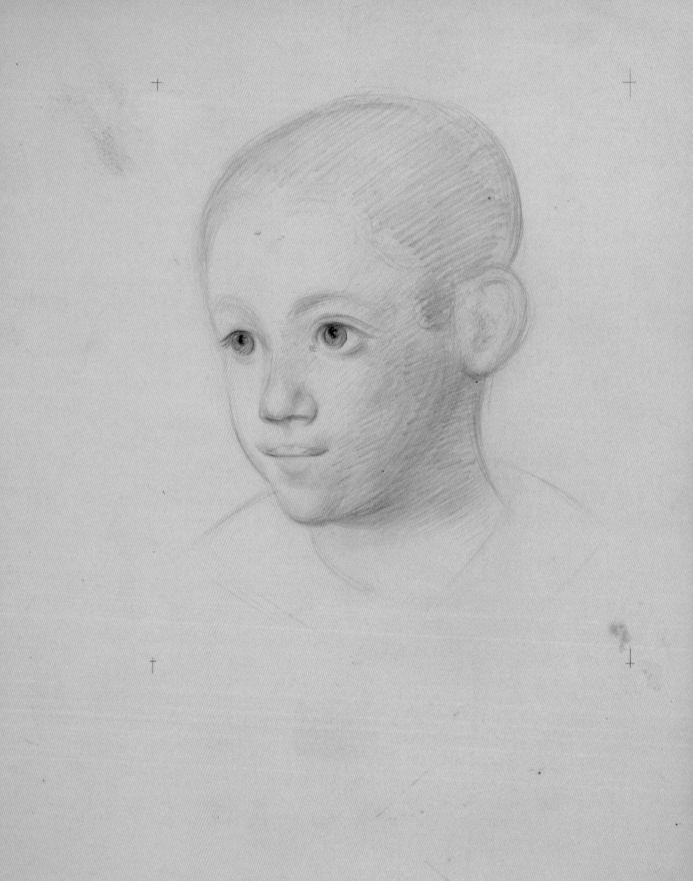

many artists had imposed onto paintings, statues, and monuments built by the fascist regime while she was growing up (Fig. 21).

Despite the technical development of her drawings and artistic work, Lina had little interest in a future in education or in academic and decorative arts. Unlike many of her colleagues from the Liceo Artistico, who moved to the Accademia di Belle Arti after graduating, she wanted to study architecture. She didn't see herself becoming an art teacher like other women of her generation or, despite her continued interest in plants, as she used to say, solely a "flower painter."

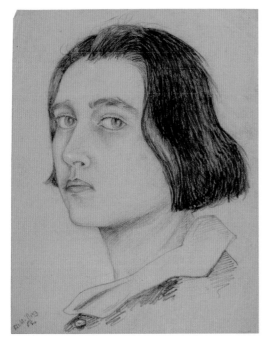 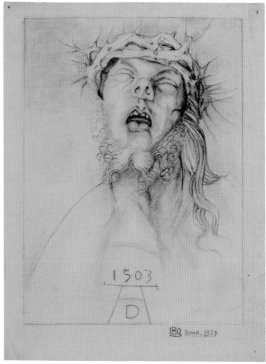

13 (*facing page*) Lina Bo, Figure studies during her education at the lyceum for the arts, no date. Pencil on card stock, 33.7 × 25.1 cm, ILBPMB Archives.

14 Lina Bo, Young woman's portrait produced during her education at the lyceum for the arts, 1931. Dry pastel on paper, 29.8 × 23.3 cm, ILBPMB Archives.

15 Lina Bo, Copy of A. Dürer's *Head of the Dead Christ* (1503) done during her education at the lyceum for the arts, no date. Pencil and dry pastel on paper, 34.3 × 26.0 cm, ILBPMB Archives.

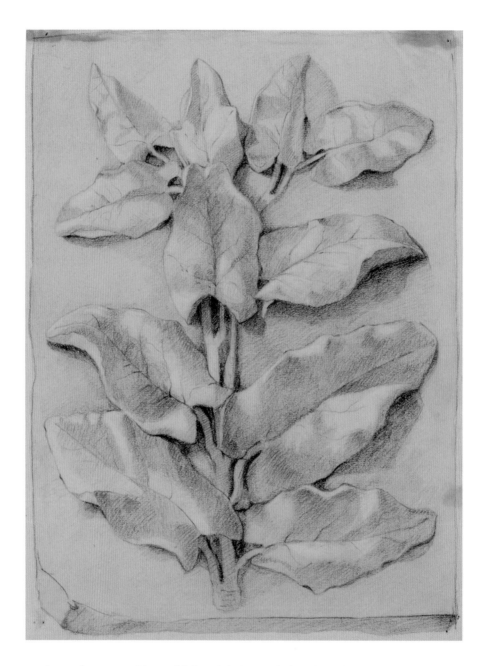

16 Lina Bo, "Mezza macchia n. 27," light and shadow study done during her education at the lyceum for the arts, 1929. Watercolor, colored pencil, and pencil on card stock, 24.5 × 18.0 cm, ILBPMB Archives.

17 (*facing page*) Lina Bo, Untitled composition, no date. Gouache and pencil on card stock, 44.8 × 29.9 cm, ILBPMB Archives.

18 (*following pages*) Lina Bo, Figure studies during her education at the lyceum for the arts, no date. Pencil and dry pastel on paper, 19.3 × 25.4 cm, ILBPMB Archives.

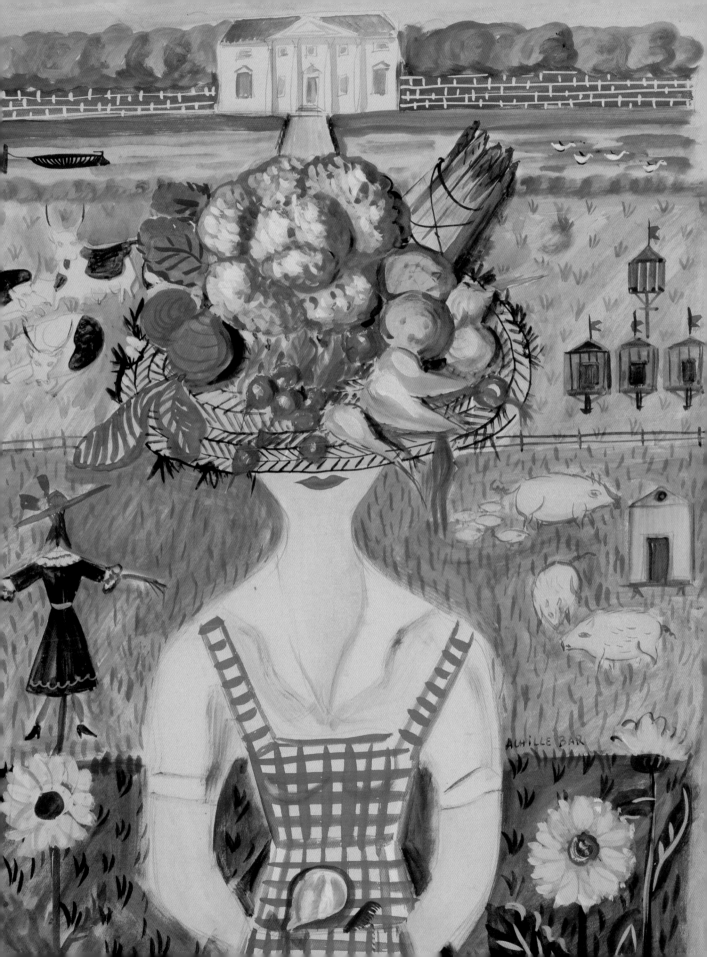

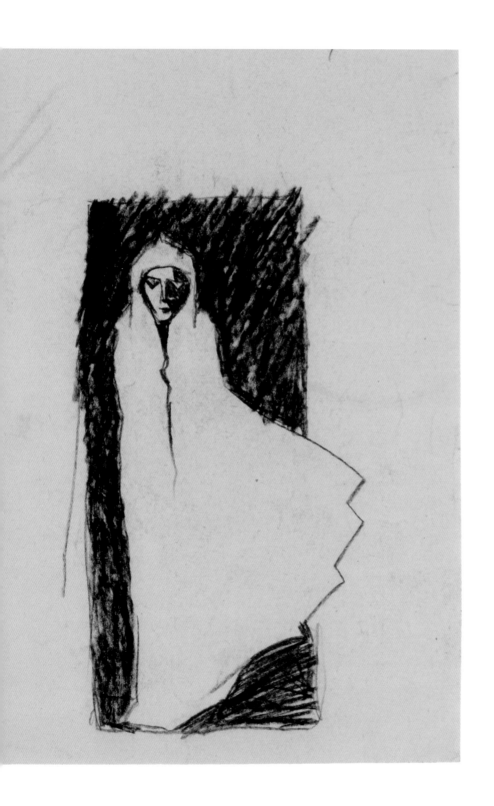

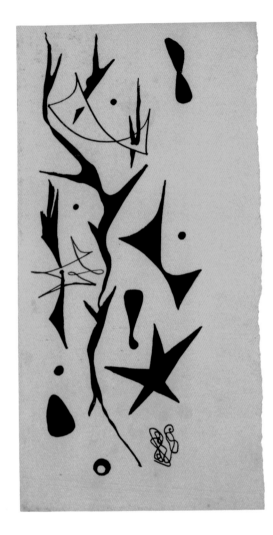

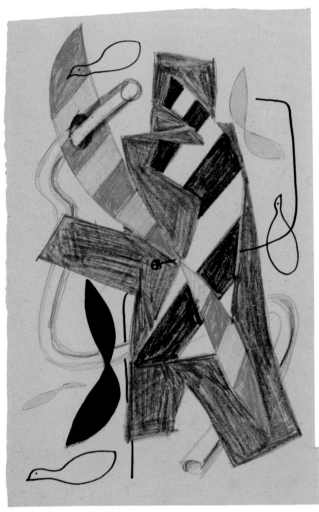

19 Lina Bo, Untitled abstract composition, no date. Gouache and pencil on paper, 18.1 × 12.0 cm, ILBPMB Archives.

20 Lina Bo, Untitled abstract composition, no date. Pencil, colored pencil, and India ink on card stock, 26.0 × 16.3 cm, ILBPMB Archives.

21 (*facing page*) Lina Bo, Untitled abstract composition, ca. 1936. Dry pastel on card stock, 18.0 × 11.7 cm, ILBPMB Archives.

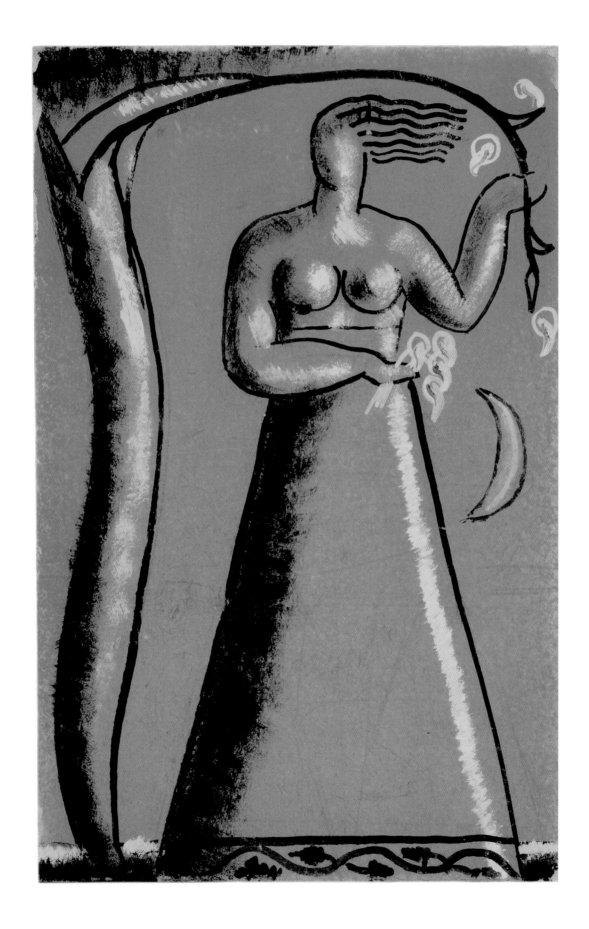

Analytical Drawings

Drawing continued to have a presence in Lina's education as an architect. She moved away from the colorful, pictorial representations of her adolescence into an exacting, analytical framework of observation and drafting and started to sign her works "Lina Bo." Unlike the many drawings she saved from her lyceum period, she kept fewer than a handful of drawings from her architectural education. One might wonder why she did not prize plans and sections from that period, but the fact that she rarely completed a full set of orthographic drawings for her projects throughout her career may be indicative of how secondary they were to her thinking in relationship to her process sketches and quasi-classical one-point perspectives.

Among the drawings she kept from her years at the school of architecture in Rome are two obscure plans for a two-story house at the sea with a straightforward internal layout. The project is unpretentious and does not reveal an elaborate spatial or formal logic. The plan is asymmetrical, but the fenestration of small openings suggests a solid, simple volume of load-bearing walls. In addition, unlike the rationalist architecture celebrated in the north of Italy and northern Europe, her project is devoid of architectural pretense. The most remarkable aspect of the remaining drawings is a pictorial detail: her use of orange gouache for the poché, the filled-in sections of walls. This choice suggests that throughout her career her design decisions were informed by unusual, bold graphic choices (Fig. 22).

The leading figures of her school were urbanist and historian Gustavo Giovannoni and architect Marcello Piacentini, who had recently become the school's director, giving him unprecedented control over professional institutions and architectural discourse. Giovannoni supported ideas of *ambientismo* (contextualism) in the remodeling of picturesque neighborhoods and in the spectacular recovery of the capital's ancient monuments. Piacentini reinforced the school's conventional tone with his official mediatory agenda for the modernization of architecture in the form of an abstracted and simplified classicism. There was little room for experimentation.

Despite this context, young students were exposed to the debate happening in the north of the country. Following the suggestions of her friend and future work partner Carlo Pagani, Lina Bo became aware of Le Corbusier's texts and of modern architecture in her last year at the school. However, throughout her life, the Swiss architect did not directly influence her work. As Pagani reminded her in a letter a few years later, she could not have been considered a rationalist architect for having drawn a bed diagonally inside a bedroom in one of her school projects.[12]

Lina Bo acknowledged later in life that the basis of her approach to architecture came from the work of Giovannoni and Piacentini, who focused more on historic investigation and preservation than on innovative design.[13] With the help of their assistants, Giovannoni and Piacentini trained architecture students such as Lina Bo to research building history, techniques, and materials in order to integrate architecture into urban restoration. She remembered Arnaldo Foschini's design classes, also known as elements of composition, with great respect.[14] The other professor she referred to was Enrico Del Debbio, who taught freehand and observation drawing, highlighting elements of classical composition and the study of Roman monuments.[15]

The courses she took included composition, plein air drawing, perspective, and descriptive geometry, all focused on the analysis of historic buildings. She also studied classical, Renaissance, and mannerist writings and treatises by Vitruvius, Giambattista Vico, and Giacomo Barozzi da Vignola. To round out this philological methodology, which consists of comparing stylistic and building elements to written documents, drawings helped Bo in the study of monument preservation.[16]

Lina Bo did not keep any of the analytical drawings of facades of Roman monuments she produced during her youth. Still, she did save at least one drawing produced by a student to whom she introduced a similar method while teaching architectural theory at the University of Bahia in Salvador in 1958. The appreciation of her student's work is evidence of how influential her own education had been.

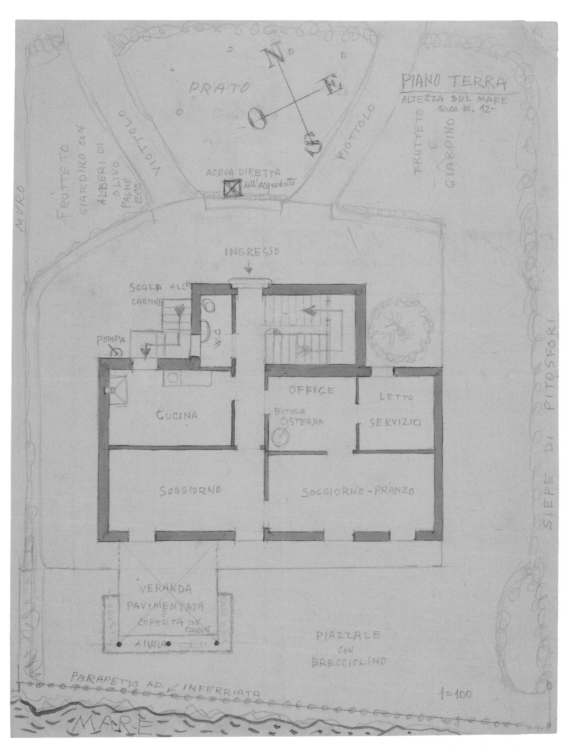

22 Lina Bo, Study for a two-story house on the coast, early 1930s. Pencil, watercolor, and gouache on card stock, 16.1 × 12.5 cm, ILBPMB Archives.

Narrative Drawings

After graduating, and at the outset of the war, Lina Bo moved to Milan, invited by her friend Carlo Pagani to form a small working partnership. A young woman in a city new to her that was frequently bombed could not find work as an architect. She began her career as a freelance illustrator and graphic designer. The work allowed her to write short articles, to gradually broaden her professional contacts, and to orbit influential Italian architects and critics in a moment in the history of Italian architecture when, as she stated later in life, "nothing was built, only destroyed."[17]

Her initial collaborative work with Pagani was for editorial projects coordinated by Pagani's mentor Gio Ponti, and for Milanese publishing houses. Although she never worked in Ponti's office, she provided services for his editorial projects, working in the improvised office Pagani organized on via del Gesù, in the center of Milan. Ponti had created *Domus* magazine in 1928 to promote the debate about the modernization of Italian architecture. During the war, he left *Domus* and decided to create *Lo Stile* to educate the middle classes about modern furniture design and interior decoration.

Lina Bo's jobs with Carlo Pagani for Ponti included writing for *Lo Stile*, and her major assignments were in graphic design: preparing page layouts and producing illustrations. She published many drawings and articles about domestic life for female audiences in *Lo Stile* and other magazines such as *Grazia*, *Cordelia*, and *Vetrina*. Illustrations tended to occupy a larger space in magazine spreads than the short texts that accompanied them, so Bo's drawings were charged with narrative purpose. The work she produced during this period—often cosigned with Pagani between 1941 and 1943—aimed at illustrating stories by other authors or describing the benefits of lighter, undecorated, and less expensive furniture.

In a time when copyright laws were in their infancy and largely disregarded, magazines had entered an era of fast reproducibility. Lina Bo quickly learned graphic techniques that were simple and efficient and at the tip of her fingers. She merged her previous experience with watercolor and gouache learned from her father and knowledge of shading theory and technical drawings from her lyceum and school of architecture education. Aside from producing elaborate original drawings to illustrate settings described in articles on interior design, she now applied her drawing and painting skills to cutting, pasting, and touching-up photographs taken from international magazines that Ponti had in his office (Fig. 23). She continued to use this collaging technique throughout her life, especially in the creation of *Habitat* magazine in Brazil in the early 1950s.

Lina Bo also collaborated on several covers for the magazine with Ponti, her father Enrico, and Pagani, together signing them with the acronym *Gienlica*, which uses their initials (Fig. 24). Those practices helped refine her visual acuity and ability for combining and transforming elements from different sources and with different meanings. Although she did not leave any document describing the process of collectively creating such images, the drawings reveal techniques and themes that remained important to her throughout her life, such as chromatic intensity; overlapping perspective (in this case cavalier projection and vanishing points); and the notion that space is occupied, inhabited, and not void.

Following Ponti's example, Lina Bo used sequential illustrations to demonstrate the advantage of simple forms and construction and manufacturing techniques, a practice she would develop and adapt throughout her later career. Her drawings began to express the dialogues between her childlike magical thinking, her academic education, and her adoption of rationalist ideas. They represented architecture, gardens, spatial layouts, modular furniture, the use of new and traditional pieces and materials, and furniture refurbishment, all highlighting the importance of simplification over the gaudiness that dominated Italian interior design (Figs. 25 through 27).

Her drawings also told stories, sometimes as a linear narrative and sometimes as visual associations. For example, the magazine illustrations she outlined and colored in collaboration with Pagani show interiors with modern furniture, allowing the reader to understand the staging of pieces in different rooms, and to simultaneously appreciate details such as new forms and materials (Fig. 28). Some of the furniture she described in those illustrations became prototypes for work she would develop in São Paulo in collaboration with Giancarlo Palanti a few years later. She used the same narrative graphic technique to illustrate interior designs she and Pagani developed independently, such as the decoration of a child's room for the owner of Mondadori Publishing House (Fig. 29).

Lina Bo also created images illustrating literary pieces and conceptual subjects, such as a complex drawing about gardens and plants, one of the themes she nurtured in her early drawings and which would thrive in her interpretation of architecture in her maturity (Fig. 30). Many of those intricate drawings are rich in form and symbolism and oscillate between traditional and modernist modes of representation, between lyricism and rationalism. She often organized them in steps to tell a linear story, almost like a cartoon and resembling medieval horror vacui compositions in which little blank space remains. Sometimes, she opted for carefully measured analysis (Fig. 31). She employed fine and short lines, limited

use of texture, single-point perspective, axonometric and cavalier representation, and bird's-eye views, displaying multiple spatial frameworks simultaneously, but never losing sight of the aspects of daily life, which she revealed in graceful, colorful details.

After 1943, with Mussolini's surrender to Nazi forces, Lina Bo continued her collaborations with Pagani and became involved in the nascent discussions about the Italian postwar reconstruction. Under these new circumstances, she stopped working with Ponti, whom she considered elitist and superficial, and engaged in new relationships, including meeting her future husband Pietro Maria Bardi as well as artists and architects who were involved in the resistance movement.

Part of the agenda of this new group of acquaintances was to propose the revision of rationalism and Italian traditions in the face of new technologies, new social relations and values, and an expected growth in urban life and housing needs. During this period, in her drawing Lina Bo expanded her understanding of modern interiors and furniture and the importance of the scale of houses and cities (Fig. 32). This image foreshadows the themes she would develop in collaboration with Carlo Pagani and Bruno Zevi in 1946 for the creation of *A, Cultura della Vita*, a magazine dedicated to postwar reconstruction efforts, and the housing projects and articles she produced soon after her move to Brazil.

In her freelance work for Italian publishers, Lina Bo produced graphics, drawings, illustrations, and prints that have survived without any clear indication of their editorial purpose. They pointed to what would be confirmed later in her architecture and design projects: that the language of drawing was intimately linked to her creative process and that architecture, as a stage for everyday life, should tell stories. She kept small sketches from this period that mocked people's habits, including those of her family members (Fig. 33), and caricatures ridiculing the unrestrained use of superfluous design ornaments (Fig. 34). She also made an elaborate drawing of the area around San Gioachimo church in Milan, near where she lived when she first moved there and which was renamed piazza Lina Bo Bardi in the early 2000s (Fig. 35).

The more complex drawings Lina Bo developed during her Milanese period have a narrative quality and reveal her passion for collecting objects. Many suggest *tableaux vivants*, in which a visual field is set up as a cabinet of curiosities, comparable to an exhibition display, like one she designed for a black-and-white magazine illustration (Fig. 36)—later used in her Brazilian museums—and a plan she devised for a furniture exposition at the Milan Triennale pavilion (Fig. 37).

Among the most articulate images she produced in the early 1940s is an

allegorical piece titled *Camera dell'architetto* (The architect's room) (Fig. 38). Based on a line drawing, this lithograph shows a desk, chair, and armoire filled with models of all types of buildings and monuments. Among the iconic architectural works depicted are a small medieval tower, a few residential buildings, a Corinthian capital, classical temples, obelisks, a pyramid, the tower of Pisa, and the Roman Coliseum. On the right side of the depicted room, a wooden console attached to the wall holds a model of a modernist house beneath another small obelisk. This simple yet outstanding illustration evokes Lina Bo's exposure to different conceptions of architecture, as well as her long-standing belief that no hierarchy should exist between historical traditions and the emergence of new aesthetic manifestations.

23 (*facing page*) Lina Bo, Editorial collage of foreign magazine cut out and photography touch-up for publication in Italian magazine, ca. 1942, ILBPMB Archives.

eleganti ~~e basse~~ vasi in grossa ceramica bianca, di forme nuove e ~~arditi~~ ardito - Il vaso grande è bruno all'esterno e giallo all'interno- quelli vicini è il piatto è interno è grigio chiaro- (da fare il decoratore.)

65

1

67

fare il fondo dalle due parti aggiustando i buchi

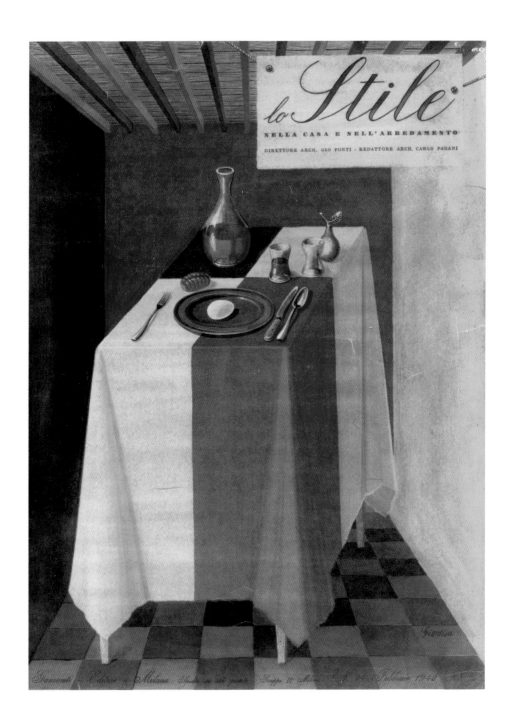

24 Gienlica, Collaborative cover illustration for *Lo Stile*, February 1942, 36.0 × 24.0 cm, ILBPMB Archives.

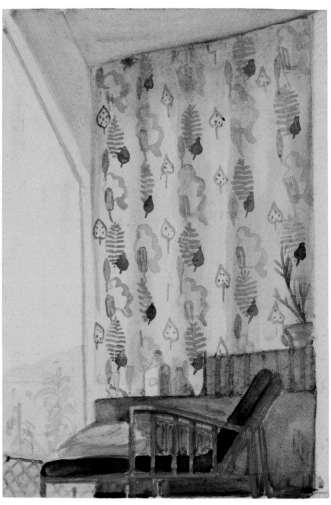

25 Lina Bo, Plant studies, no date. Pencil and watercolor on card stock, 28.1 × 19.0 cm, ILBPMB Archives.

26 Lina Bo, Interior study, no date. Pencil and watercolor on card stock, 18.4 × 12.8 cm, ILBPMB Archives.

27 Lina Bo, Comparative illustration of traditional furniture for *Lo Stile* magazine, ca. 1941. Ballpoint pen and gouache on paper, 32.8 × 23.3 cm, ILBPMB Archives.

28 *(facing page)* Lina Bo, Comparative illustration of modern furniture and interior design for *Lo Stile* magazine, ca. 1941. Ballpoint pen and gouache on paper, 32.8 × 23.5 cm, ILBPMB Archives.

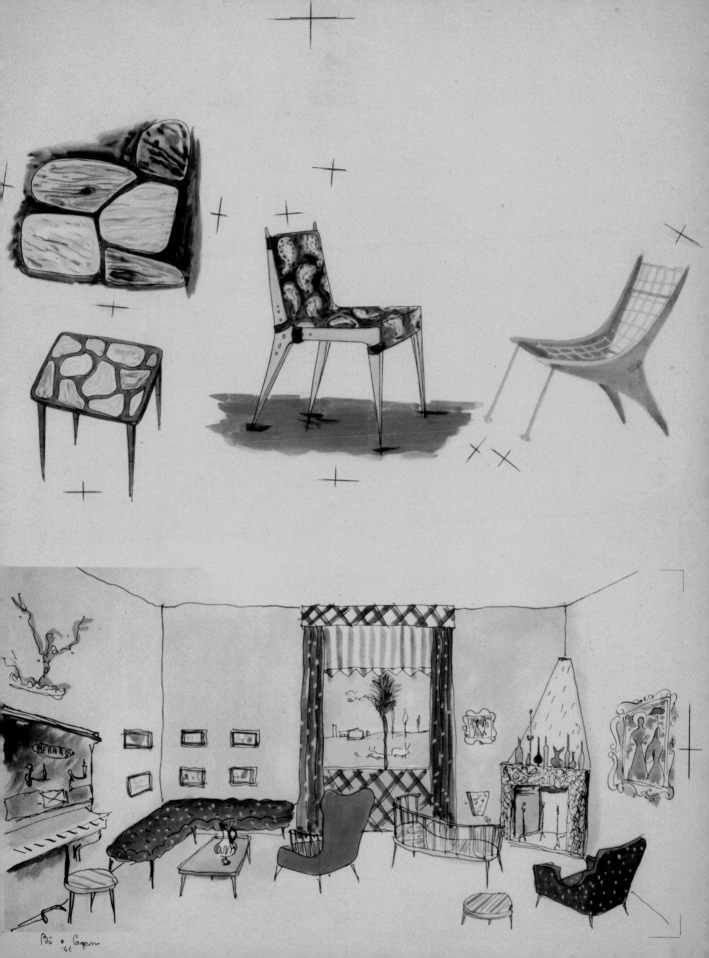

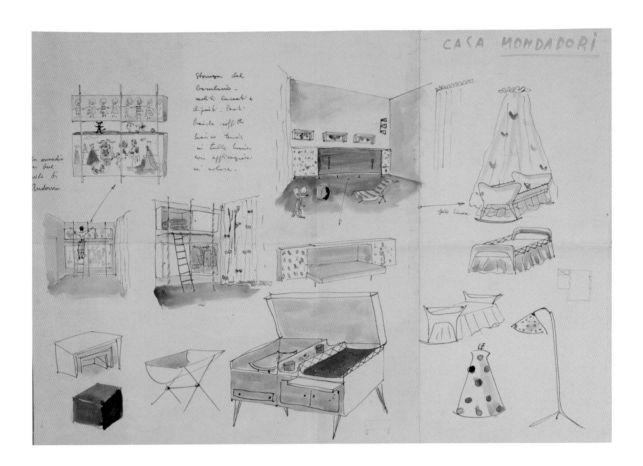

29 Lina Bo, Illustration of a child's room interior design for Mondadori Publishing House, ca. 1941–42. Watercolor, gouache, pencil, and colored pencil on card stock, 37.7 × 53.8 cm, ILBPMB Archives.

30 (*facing page*) Lina Bo, Illustration of gardens, ca. 1940. Watercolor, gouache, and India ink on card stock, 46.6 × 34.4 cm, ILBPMB Archives.

31 (*following page*) Lina Bo, Illustration of model house, early 1940s. Watercolor, pencil, colored pencil, and India ink on card stock, 24.6 × 35.9 cm, ILBPMB Archives.

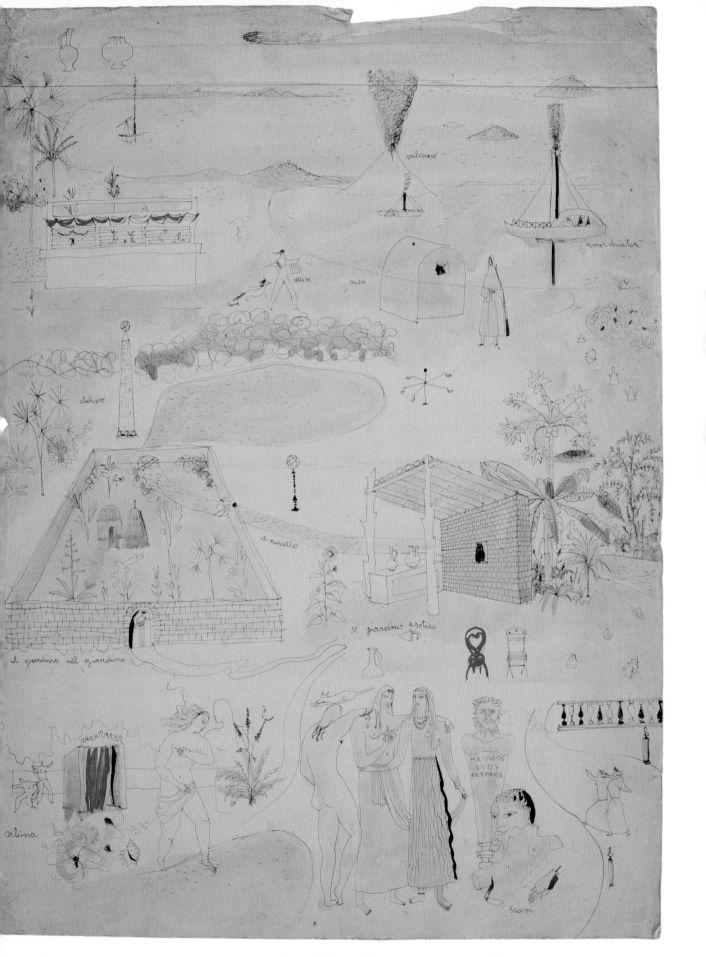

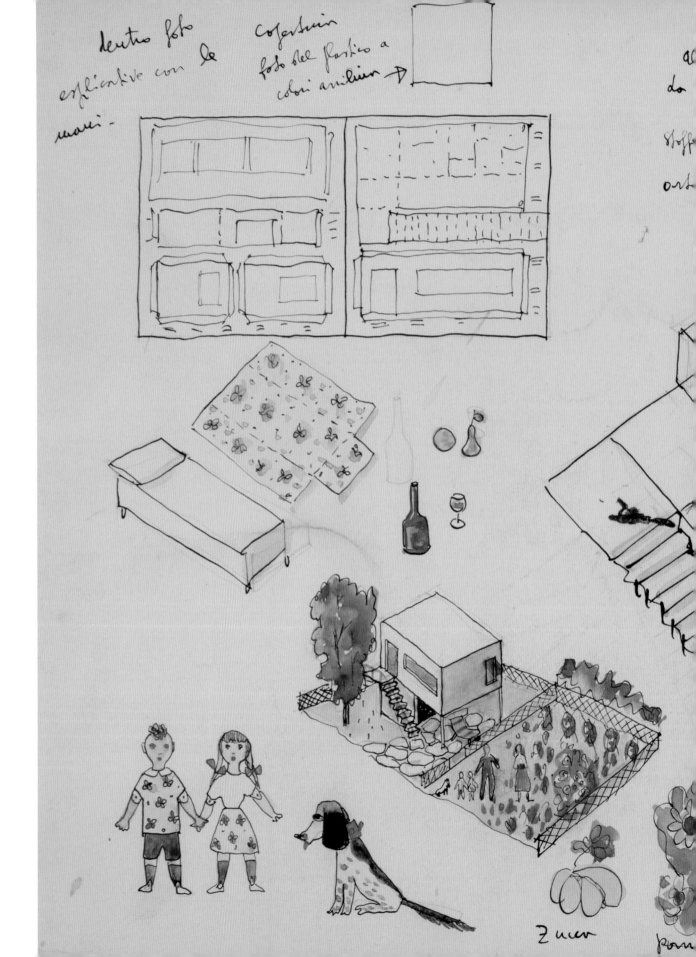

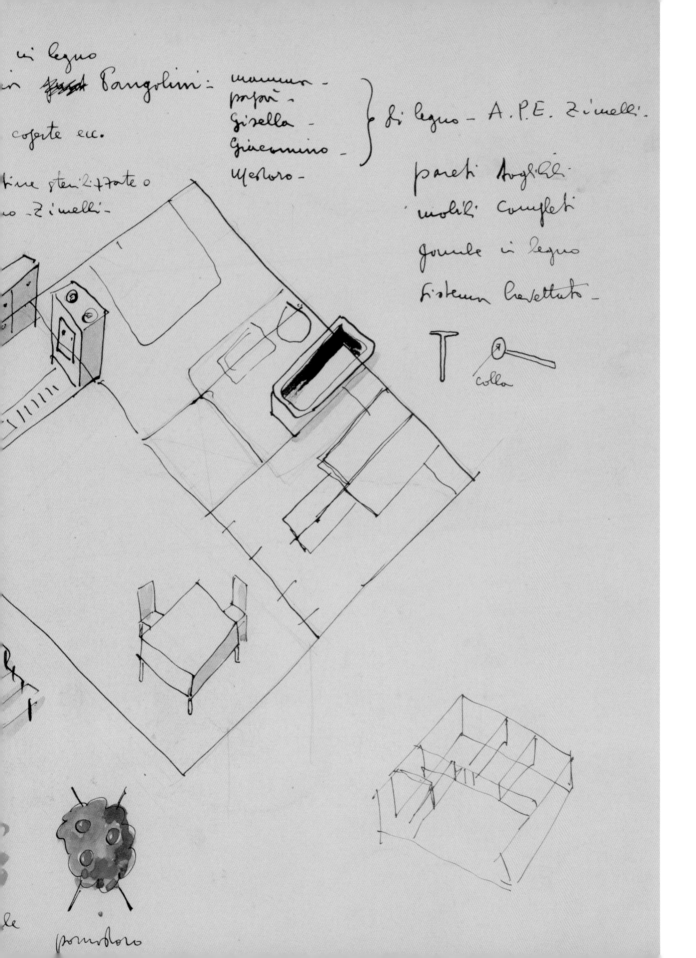

in legno

~~in pret~~ Pangolini: mmmmm -
 papoi -
 Gisella -
coperte ecc. Giacommino -
 Uestoro -
tine sterilizzate o
o -Zinelli -

} di legno - A.P.E. Zinelli.

pareti Anglili.
mobili completi
gamole in legno
Listeme brevettato -

colla

le
pomodoro

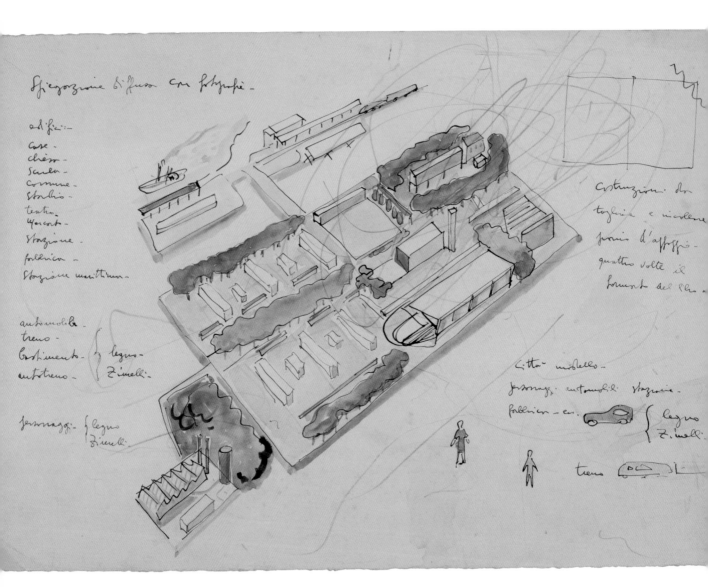

32 Lina Bo, Illustration of model city, early 1940s. Watercolor, colored pencil, and India ink on card stock, 24.7 × 35.9 cm, ILBPMB Archives.

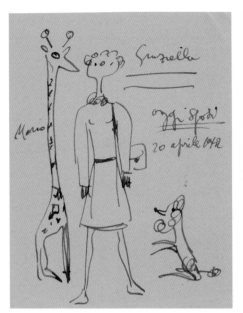 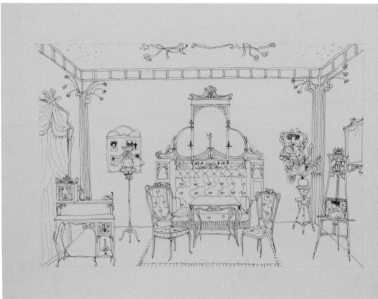

33 Lina Bo, Caricature portraying her sister Graziella's wedding, 1942. India ink on paper, 14.0 × 11.0 cm, ILBPMB Archives.

34 Lina Bo, Caricature depicting gaudy interior decoration, 1942. India ink on Canson paper, 22.9 × 32.5 cm, ILBPMB Archives.

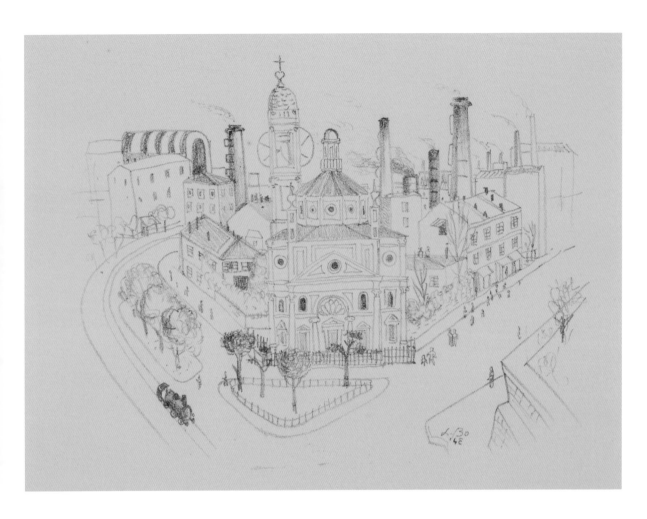

35 Lina Bo, San Gioachimo church and surroundings produced while temporarily living at Principe di Savoia Hotel, 1943. India ink on cardboard, 24.1 × 35.2 cm, ILBPMB Archives.

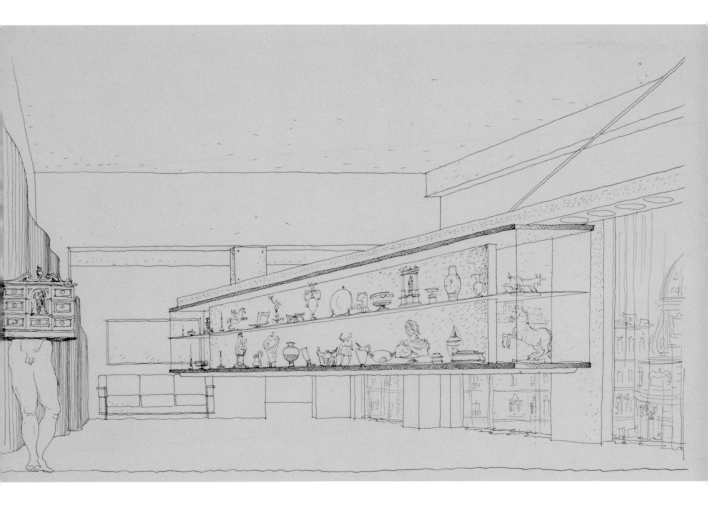

36 Lina Bo, Illustration of exhibition display cabinet, early 1940s. India ink on card stock, 17.5 × 27.9 cm, ILBPMB Archives.

37 (*following page*) Lina Bo, Study for theatrical exhibition display at Milan Triennale Pavilion, ca. 1946. Watercolor, gouache, pencil, and India ink on cardboard, 31.4 × 43.3 cm, ILBPMB Archives.

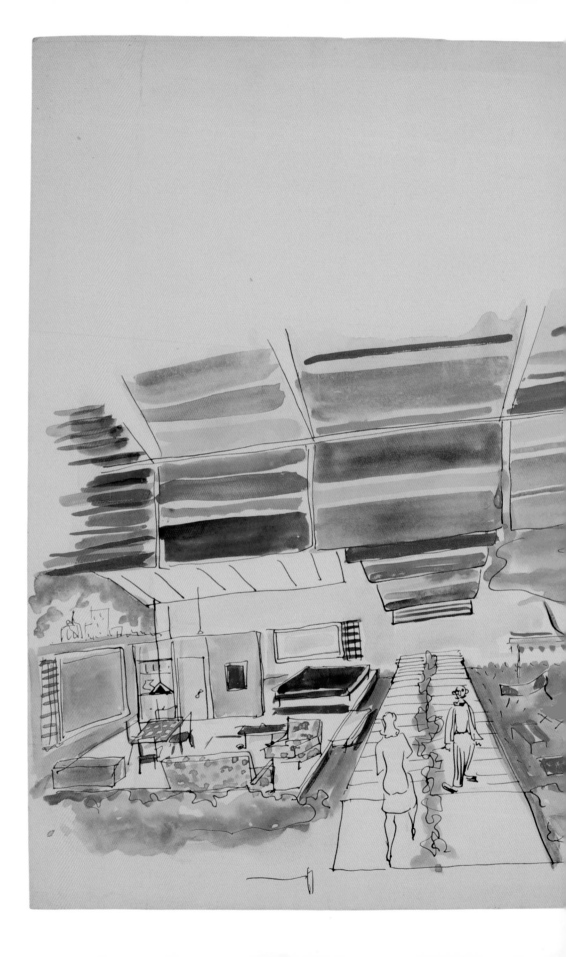

Liberty

altezza 130

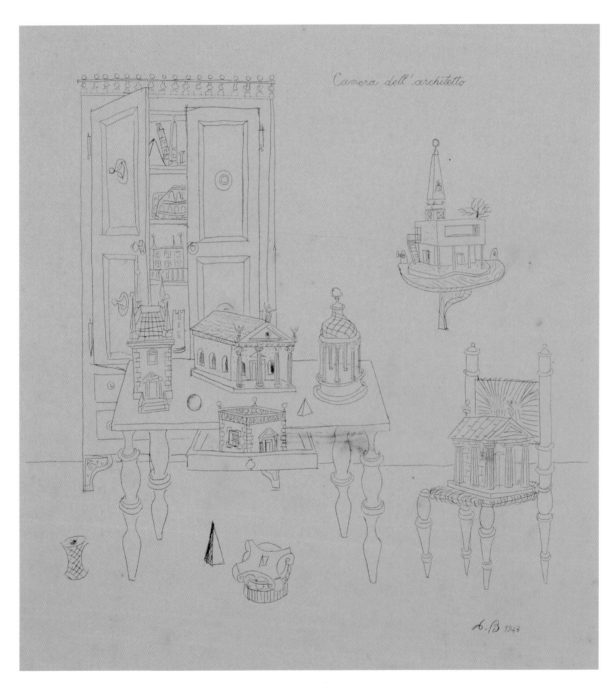

38 Lina Bo, "Camera dell'architetto" (Architect's room), 1943. Lithograph on Canson paper, 22.0 × 17.0 cm, ILBPMB Archives.

Drawing from the People

Following the end of the war, at age thirty-one, Lina Bo married the prominent, controversial art dealer and journalist Pietro Maria Bardi, and the couple moved to Brazil in October of 1946. Lina Bo took Bardi's last name. The trip was intended to be a temporary commercial enterprise for Bardi's Roman gallery, but the work opportunities they discovered in Brazil kept them permanently in the country. He loaded his artworks in large containers, and she carried her art supplies in her personal luggage. Bo Bardi documented their journey in several sketches, including a fine line drawing of naval wreckage and the unpredictable Vesuvius framed in a window on the ship's deck (Fig. 39). As she and her husband approached their new land, she used watercolors to depict the greenish blue, tropical waters, and historical towns of the northeastern coast of Brazil (Fig. 40).

Once installed in her room in Rio de Janeiro's Hotel Serrador, Bo Bardi completed an evocative visual record of her early encounter with Brazil: a lively watercolor representing the city's old theater district. She finished the drawing three days after arriving in Rio and sent it to her father, who copied it, vicariously trying to experience both her reminiscences and her new adventure (Fig. 41).

This elaborate image depicted many of the elements that had been part of Bo Bardi's popular repertoire, and it helped her identify with her new country. The tall corner window of her room framed a view of lush trees, colorful buildings, and vibrant gatherings of people. She drew the crowds at street level as they moved among the traffic and a truck carrying groceries, where two men appear sitting atop wooden boxes and holding an umbrella, as if on a carnival float. Her attention was drawn to the coexistence of different worlds: wealth and poverty, formality and spontaneity, courtesy and rudeness, and light and dark hues. Her first impression was that Brazil had no middle class, only "the aristocracy, and the people."[18]

Bo Bardi ventured into the everyday life of the city and met prominent Brazilian architects including Oscar Niemeyer and Lucio Costa, neither of whom paid her significant attention, either at that moment or during her life. Niemeyer dismissed many of her ideas, stating, "Europeans make things seem too complicated."[19] Her conversations with other architects were also discouraging. Although she would not later cite the source, she recalled hearing, "You're so dull, so many drawings."[20]

This comment might have been spurred partly by masculine chauvinism against a young, foreign, woman architect, and partly because Lina Bo Bardi's

training in classical representational traditions along with her life in the recently politicized Milanese rationalist milieu did not resonate well in Rio de Janeiro. The emerging modern architecture in Brazil, as she would write a few years later, "didn't have much time to stop and think; it was born suddenly, like a beautiful child."[21] Brazilian modernism lacked the rationalism she was used to. It lacked infrastructure like established manufacturing traditions, industrial production systems, and labor organizations, yet it thrived, despite great improvisation. Bo Bardi soon concluded that Brazilian architects should not try to emulate European values, and instead look at the wealth of the country's spontaneous culture for inspiration.

She was particularly amazed by Costa's remark that sometimes architects in Brazil just sketched with a stick in the dirt to explain a construction detail to a foreman. She was fascinated by the romanticism of his comment. Instead of intimidating her, Bo Bardi's encounter with modernist Brazilian architects may have helped her distance herself from the rationalist demands of her European training.

Her conversation with Costa later inspired her to compare such spontaneous and ephemeral gestures on the ground to the medieval method of French master builder Villard de Honnecourt.[22] This was the beginning of the affirmation of her lyrical approach to architecture and design and of the increasing freedom she took toward drawing as a language and as part of her design process.

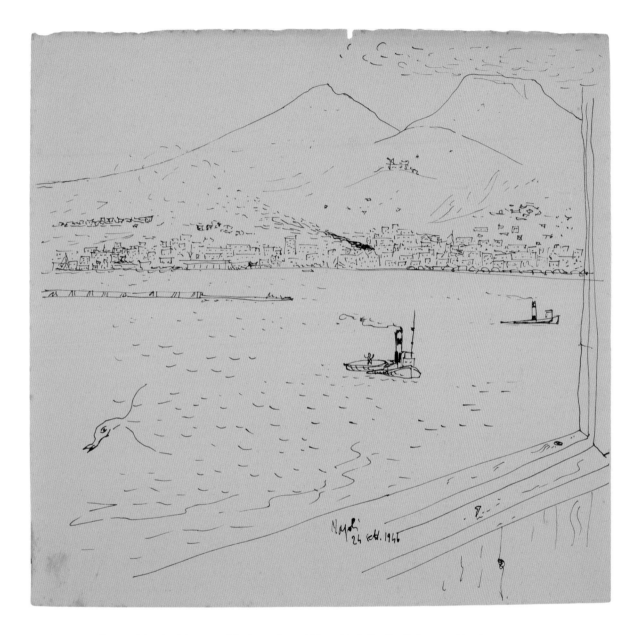

39 Lina Bo Bardi, Travel sketch of the port of Naples as she and Pietro Maria Bardi sailed away to Brazil, 1946. Watercolor and pencil on paper, 23.1 × 24.2 cm, ILBPMB Archives.

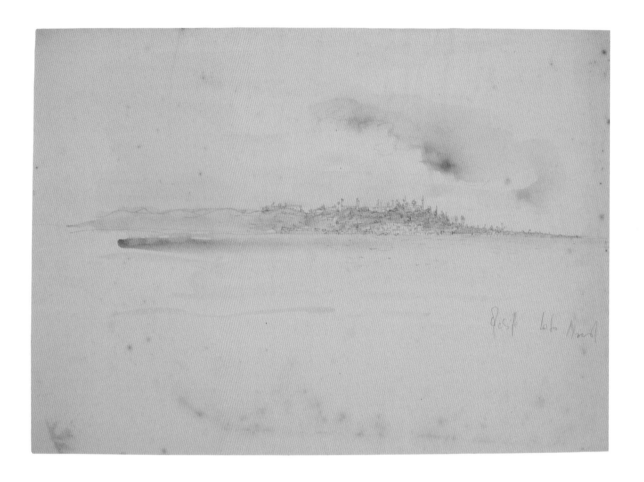

40 Lina Bo Bardi, Travel sketch of Olinda, Pernambuco, navigating along the northeastern coast of Brazil, 1946. Watercolor and pencil on paper, 21.0 × 29.6 cm, ILBPMB Archives.

41 *(facing page)* Lina Bo Bardi, Passeio Público Park and theater district, Rio de Janeiro, 1946. Watercolor and India ink on paper, 24.2 × 22.3 cm, ILBPMB Archives.

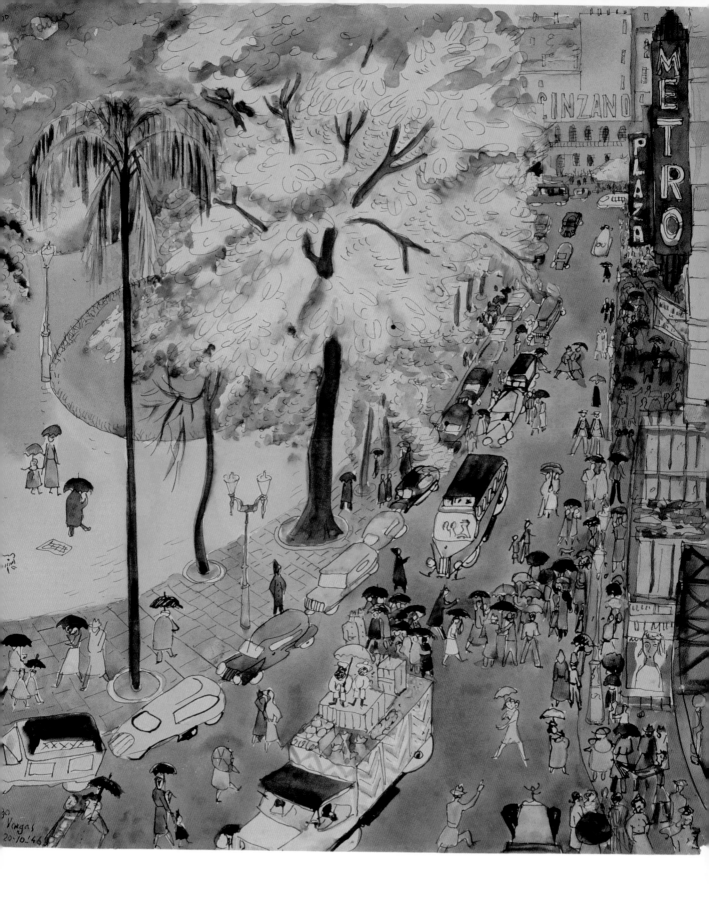

Drawing a Hybrid Identity

The first decade Lina Bo Bardi spent in her adopted country was productive and transformative. This was a period of emancipation from what she described as the "schemes of Italian culture."[23] In this new context, her drawings thrived. She moved to São Paulo in 1947 and committed to working on the creation of the Museum of Art of São Paulo (MASP), in collaboration with her husband and their patron, press magnate and philanthropist Assis Chateaubriand. MASP soon became a cultural powerhouse, and Bo Bardi put her drafting and drawing abilities to use in many controversial proposals that both affirmed and resisted the trends of Brazilian architecture.

Relying on her close intellectual relationship with her husband, Bo Bardi designed innovative museum interior spaces, display mechanisms, furniture, and exhibitions. The modernist high-rise that would house both Chateaubriand's new press headquarters and MASP in downtown São Paulo was nearing completion, and Bo Bardi had just a few weeks to improvise an entranceway leading into the exhibition hall, auditorium, and administration office in the floor above the street level. She composed a light, simple geometric panel with wooden slats leaning against the unfinished street facade with room for posters and a vitrine (Fig. 42).

With Milanese elegance and precision, she designed moveable metal chairs for the auditorium (Fig. 43), which were later replaced by foldable ones in wood and canvas. She also designed clips to hold paintings from the nascent collection against metal rods going from floor to ceiling, moving them away from the walls, emulating the work Franco Albini had proposed in Italy (Fig. 44). In addition, she produced several carefully drafted perspectives of the main, open exhibition hall, one of which contained screens and panels similar to the museum entrance and a long vitrine evocative of the drawing she had produced a few years before (Fig. 46).

After MASP opened in 1948, Bo Bardi helped create and designed the influential *Habitat* magazine, which was published between 1950 and 1954, with the same passion and graphic notions from her Italian editorial experience. Her drawings ranged from provocative covers (Fig. 45), following the tone of *A* magazine, to illustrations of traditional Brazilian architecture (Fig. 47), reminiscent of the many drawings of baroque buildings in Rome that she developed in her youth. Complementing the museum's program, she also taught at the Instituto de Arte Contemporânea and was invited to teach architectural theory at the University of São Paulo a few years later.

In 1948, Bo Bardi curated her first exhibition at MASP, a show dedicated to chairs, displaying pieces from medieval Tuscany to modernist European designers, which helped launch a design partnership between the gallery and another émigré architect from Milan, Giancarlo Palanti. The partnership, Studio Palma, excelled in retail interior design, and it created a line of furniture using industrial and natural Brazilian materials. Although Studio Palma ended up closing in 1950, its collaborative work was remarkable. Lina Bo Bardi left a series of her strikingly synthetic work sketches for several imaginative pieces, from tables and chairs to decorative objects evocative of her Milanese background (Figs. 48, 49, and 50).

During this period, Bo Bardi designed a few unrealized architectural projects, some of them for Chateaubriand's ambitious press headquarters and others as theoretical exercises or as spec work. Among her drawings are two perspectives representing different studies for Chateaubriand's television network, including a detailed modernist facade in India ink (Fig. 51) and a touched-up photograph for one of the recording studios done in the same fashion as many of the images she produced for Ponti's magazines (Fig. 52).

With the political help of Chateaubriand, Bo Bardi planned an agricultural exposition in São Paulo for which she designed pavilions and a graphic identity. Although the official poster announcing the event contained stylized images, one of the studies she produced for it is among her most striking graphic pieces. Against an abstract night-like landscape with a golden falling star, she collaged the photograph of a rural house—one of the favorite architectural themes she had inherited from her neorealist Italian contemporaries—and drawings of agricultural tools and an imaginative blue cow and calf whose markings resemble pink flowers (Fig. 54). Not only does this image summarize many of the graphic techniques she developed, it also represents a hybrid conception of design and the search for aesthetic and technical simplification. In it, Bo Bardi's easiness in the medium is expressed with grace and the sense of magical realism she carried from her childhood, which she identified in Brazilian everyday culture.

During this period, she also designed two iconic works and produced a series of sketches for them: Her renowned bowl chair (Fig. 53), with drawings in which she explored two simple circular structures, associating the exacting geometry of the object holding the seat with the changing softness of colors and materials holding the body, and her first built architectural project, the glass house in which she would spend her life, a hybrid structure merging industrial and rural references, completed in 1952.

The house, originally intended as a studio-residence for visiting faculty at MASP's Instituto de Arte Contemporânea, was conceived as a live-work pavilion. After having sketched a first idea for a rectangular, gridded, and glazed wood-frame structure, Bo Bardi prepared several study variations (Fig. 55), always pursuing simplicity of form and openness to the leafy hills of the Morumbi subdivision in São Paulo. Once the Bardis decided to transform it into their residence, Bo Bardi maintained the modernist glazed plan, adding a service block on the back that resembled rural constructions. Some of the perspectival sketches she produced at the time reveal the sociability she expected the house to have in her and her husband's everyday life—she even included both of them in one of the drawings—and in their taste for hosting animated cultural encounters (Fig. 56).

These two iconic projects flirted with larger developments within Brazilian architecture and design in the late 1940s and early 1950s. Unlike the European (specifically Corbuserian) references adopted by the first generation of Brazilian modernists in Rio de Janeiro, the emerging postwar architectural culture in São Paulo was looking toward developments in North American architecture, motivated by the growing political interference of the United States in Brazil and by direct exchange between architects from the two countries, including lectures and publications by Richard Neutra in São Paulo.

During this period, Bo Bardi produced a large spec drawing for a residential subdivision. This time, the houses resemble her own house and the main town pavilion hints at Mies Van der Rohe's glass blocks, introducing her interest in a style that she would revisit in her design for MASP's permanent building in São Paulo (Fig. 57). This colorful drawing is meaningful, as it suggests Bo Bardi's way of creating visual narratives to describe complex, multiscalar ideas as well as her negotiation between traditional Italian modes of representation and her exposure to new aesthetic values.

In addition to working on design projects and for MASP, Bo Bardi taught design theory at the school of architecture at the university of São Paulo between 1955 and 1957. During this period, she produced a tenure thesis, published as *Contribuição propedêutica ao ensino da teoria da arquitetura* (Introductory Contribution to the Teaching of Architectural Theory) in 1957, which contains some of the most articulate texts she ever wrote about drawing. Bo Bardi emphatically avoided describing drawing as an artistic practice and affirmed the need for clear ideas rather than impressive images. "Architecture, as the art of drawing, is born out of and lives off of it," she stated. "However, not in the sense of an artwork,

which is harmful to architectural drawing. Architectural sketches do not conform to artistic representation; they obey the needs of architecture. When I talk about drawing, I refer to the sense it had in the Renaissance, that is, its mathematical sense."[24] She added that "architects [should] have access to [Gaspard] Monge's representational method,"[25] that is, the invention of descriptive geometry by the Enlightenment's major French mathematician.

Bo Bardi relied on her editorial experiences in Italy and later in Brazil to convey her regret to students that architects increasingly opted for other kinds of "spectacular presentation ranging from perspective for clients to moving models and touched up images to fit into photomontages in a falsified vision of reality."[26] Although her drawings were colorful and sometimes picturesque, she insisted that architectural drawing should not be confused with pictorial representation or scenic perspectives, "unfortunately the preferred method to present a project to laypeople."[27] Instead, she strongly recommended that students learn freehand drawing, "with clean, dry, analytical strokes, in the architect's way."[28]

Her goal was to keep deliberation and action together by "getting the hand used to analytical independence," and for drawings to be "absolutely modest, in the way that architect Giuseppe Pagano defined [them] in the Politecnico di Milano: 'to draw with one's left hand.' "[29] Ultimately, she believed that drawing should "convey technical and ethical conscience to the architect," underlining the idea that "architecture is not an art" and should transcend such boastful self-expression. "Professional ethics starts with artistic modesty," Bo Bardi concluded, demonstrating those beliefs through her everyday practice; her love of drawing; and her search for buildings, objects, and spaces that were straightforward and accessible to all.[30]

42 Lina Bo Bardi, Study perspective for temporary entrance to the Museum of Art of São Paulo on 7 de Abril Street, 1947. Watercolor, pencil, and India ink on paper, 31.5 × 47.5 cm, ILBPMB Archives.

43 *(facing page)* Lina Bo Bardi, Design for auditorium chair, Museum of Art of São Paulo on 7 de Abril Street, 1947. Pencil and India ink on paper, 29.9 × 21.0 cm, ILBPMB Archives.

GRASSELLI & CIA. LTDA

Av. Macuco, 260 (Indianopolis)
Dep. R. Joaquim Floriano, 225 - (Itaim)
Caixa Postal, 5079 - SÃO PAULO

MECANICA:
Construções e serviços d
maquinas.
MARCENARIA:
Moveis, artefatos de made
iras e arredamentos em ge
FUNDIÇÃO:
De legas leves em conquilh
VIDROS:
Venda e colocação; Vidro
espelhos e molduras.

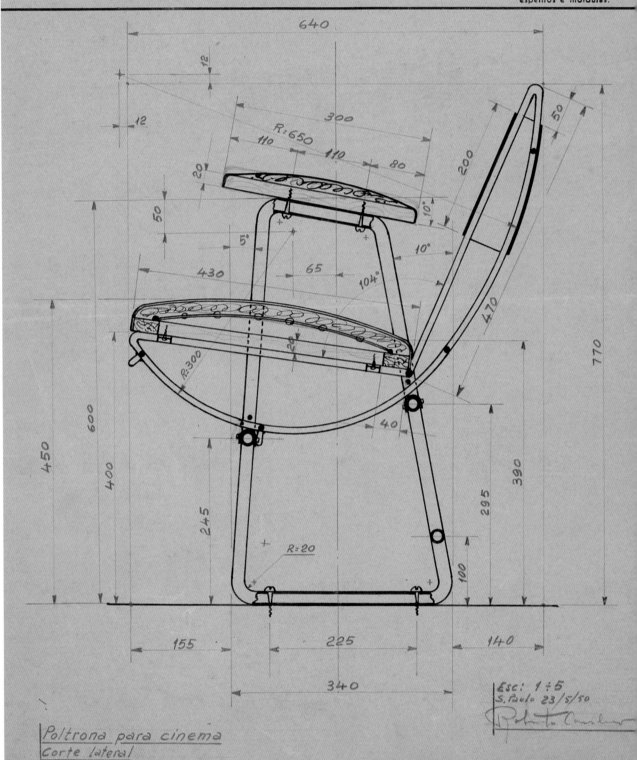

Poltrona para cinema
Corte lateral

Esc: 1÷5
S. Paulo 23/5/50

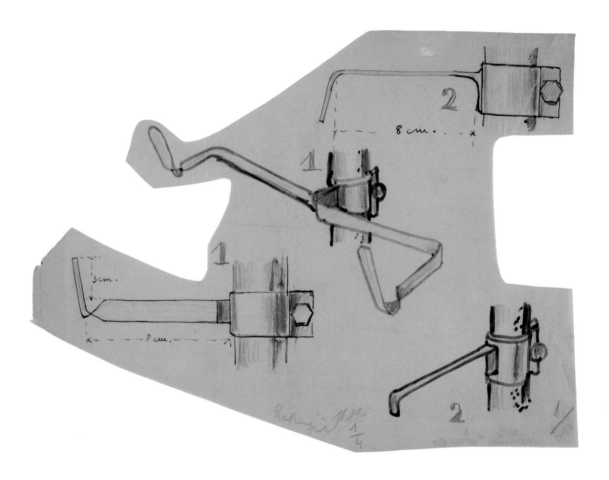

44 Lina Bo Bardi, Detail sketches for moveable exhibition display, Museum of Art of São Paulo on 7 de Abril Street, 1947. Felt pen on paper, 30.1 × 37.9 cm, ILBPMB Archives.

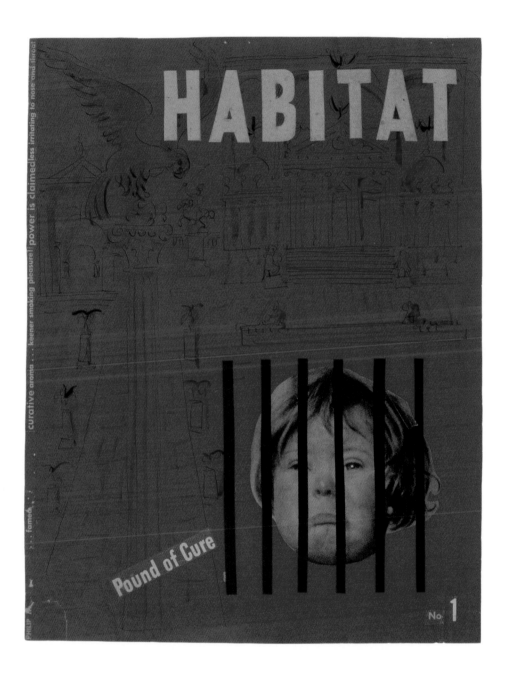

45 Lina Bo Bardi, Cover study for the first edition of *Habitat* magazine, 1950. India ink and collage on paper, 30.1 × 23.4 cm, ILBPMB Archives.

46 (*following pages*) Lina Bo Bardi, Perspective of main exhibition hall with display panel layout, Museum of Art of São Paulo on 7 de Abril Street, 1947. India ink on card stock, 69.8 × 99.7 cm, ILBPMB Archives.

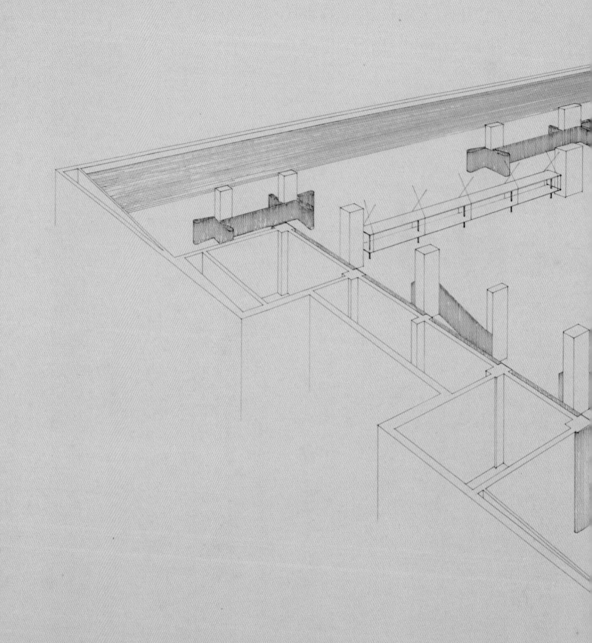

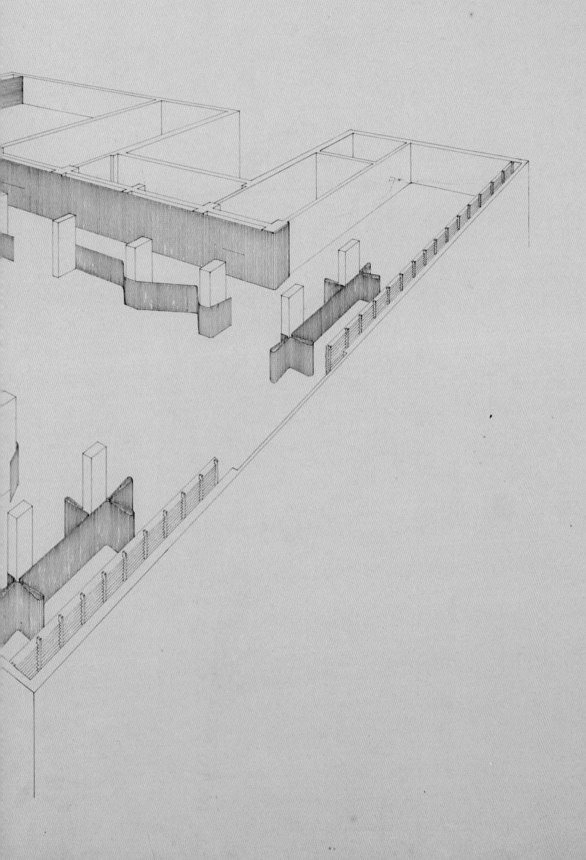

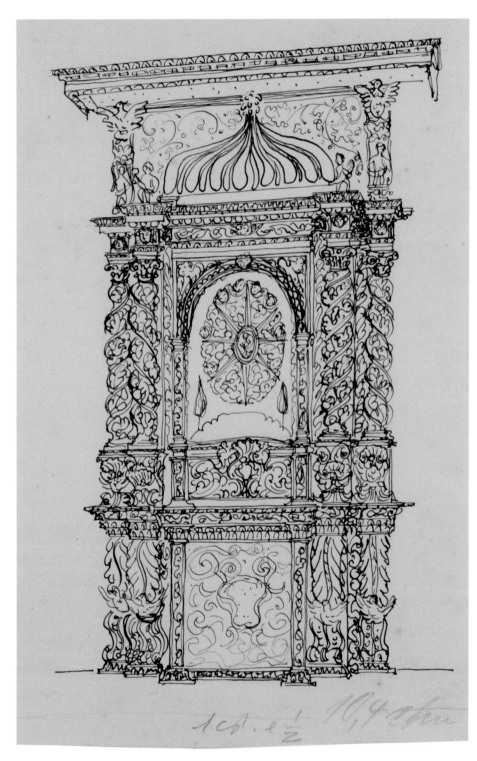

47 Lina Bo Bardi, Illustration of Brazilian baroque church altar for *Habitat* magazine, early 1950s. India ink and pencil on paper, 22.1 × 19.4 cm, ILBPMB Archives.

48 Lina Bo Bardi, Sketch for serving cart (Studio Palma), ca. 1949. India ink on paper, 10.6 × 11.8 cm, ILBPMB Archives.

49 Lina Bo Bardi, Chair study sketches (Studio Palma), 1948. India ink on paper, 25.8 × 20.3 cm, ILBPMB Archives.

50 Lina Bo Bardi, Study sketch for ceramic pieces (Studio Palma), ca. 1948. India ink on paper, 22.5 × 16.1 cm, ILBPMB Archives.

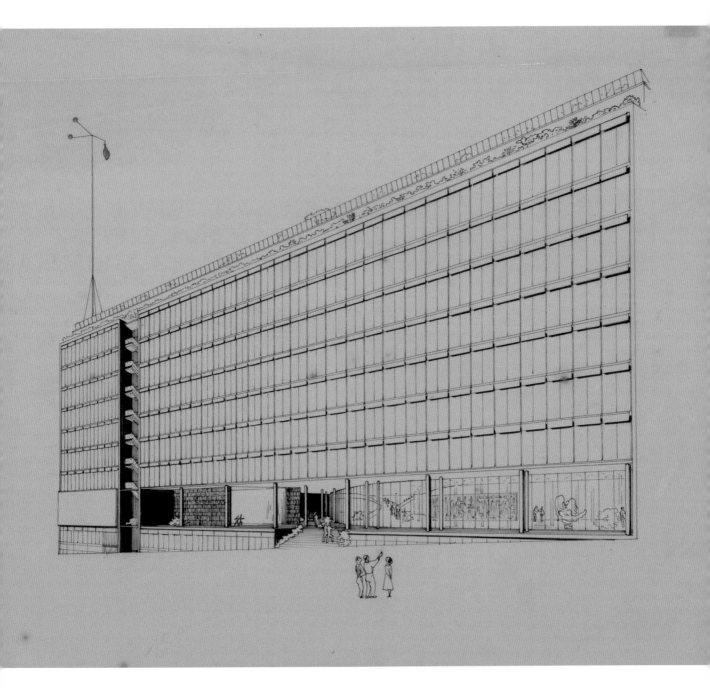

51 Lina Bo Bardi, Exterior perspective for Diários Associados headquarters (Studio Palma), 1947. India ink on paper, 36.5 × 36.7 cm, ILBPMB Archives.

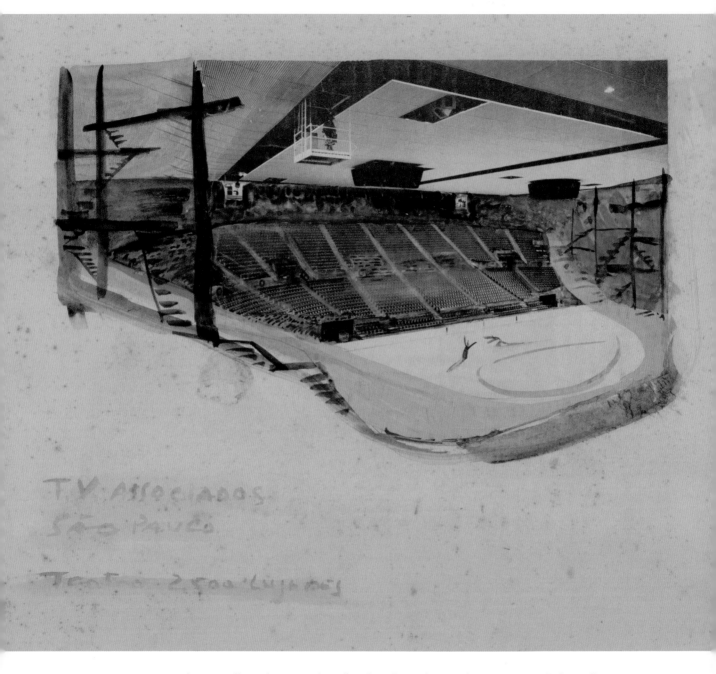

52 Lina Bo Bardi, Interior perspective collage for Taba Guaianazes Theater, 1951. Touched-up collage with gouache, felt pen, and photocopy on card stock, 38.4 × 56.2 cm, ILBPMB Archives.

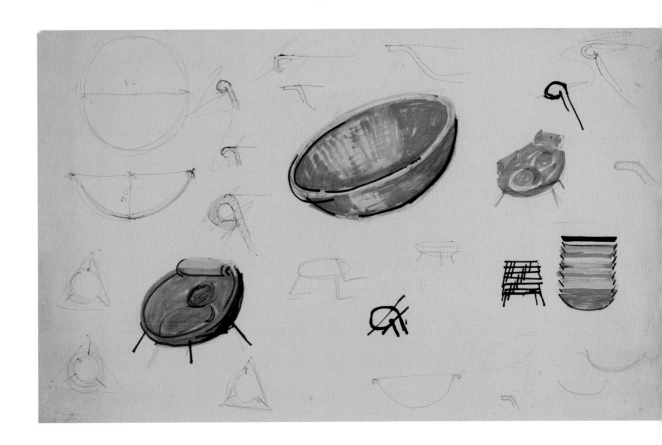

53 Lina Bo Bardi, Study sketches for Bardi bowl chair, 1951. Felt pen, pencil, India ink, and oil pastel on paper, 28.6 × 47.5 cm, ILBPMB Archives.

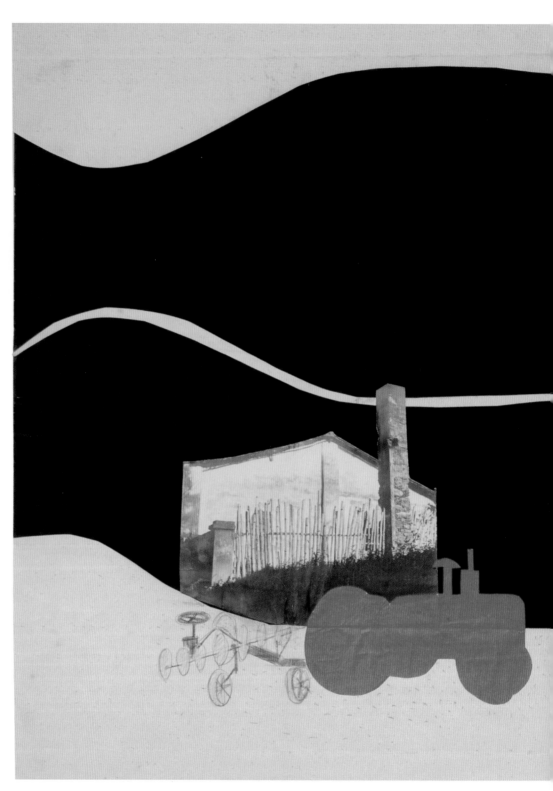

54 Lina Bo Bardi, Illustration for poster, Agricultural Exposition, São Paulo, 1951. Gouache, pencil, colored pencil, and oil pastel collage on paper, 56.6 × 81.3 cm, ILBPMB Archives.

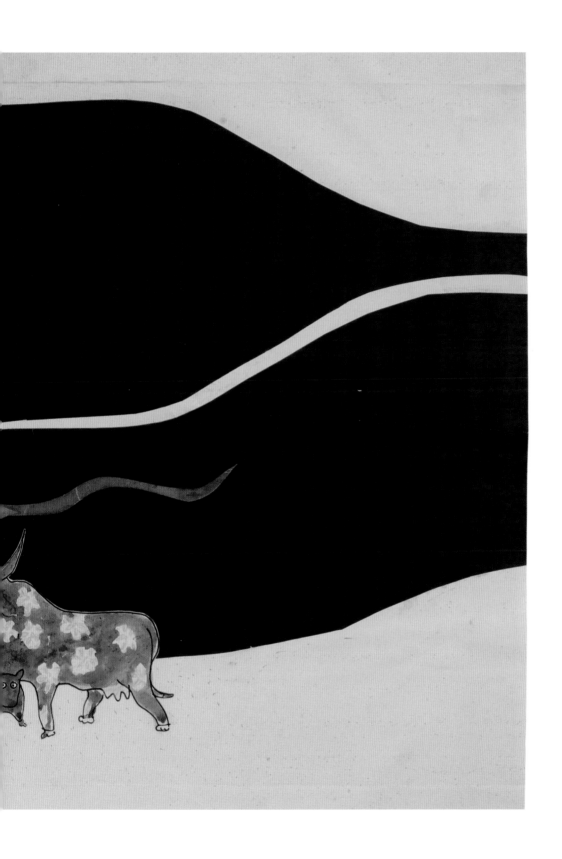

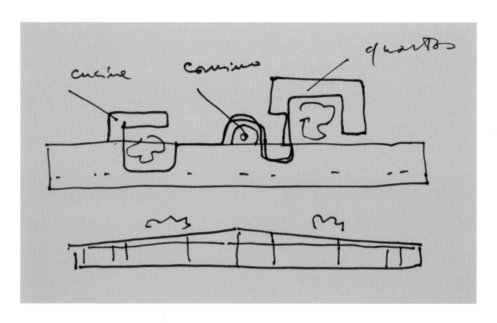

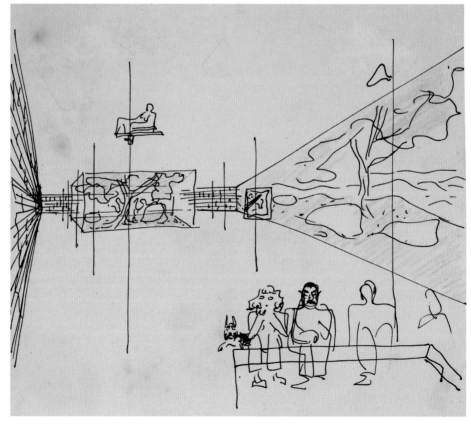

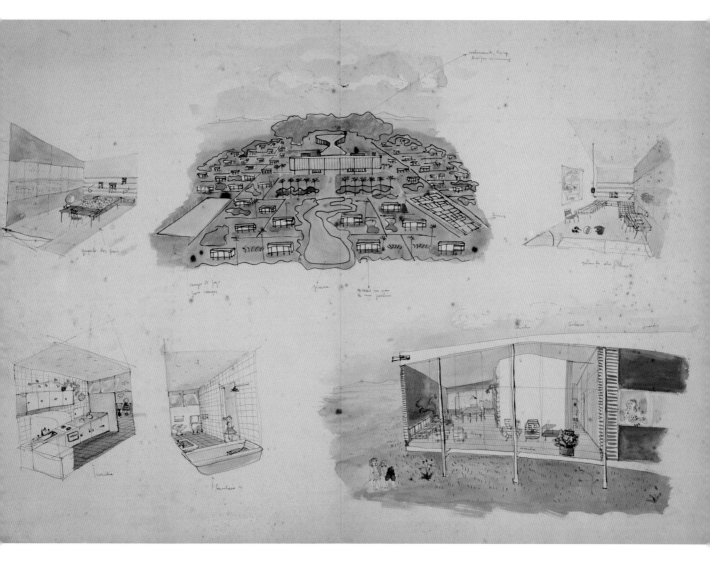

55 (*facing page, top*) Lina Bo Bardi, Initial study for the Glass House, plan and elevation, ca. 1949. Felt pen on paper, 3.9 × 15.8 cm, ILBPMB Archives.

56 (*facing page, bottom*) Lina Bo Bardi, Initial study for the Glass House, perspective portraying herself and P. M. Bardi, ca. 1949. Felt pen on paper, 10.9 × 11.8 cm, ILBPMB Archives.

57 (*above*) Lina Bo Bardi, Studies for urban settlement with prototypical houses, 1951. Felt pen, pencil, India ink, and oil pastel on paper, 70.0 × 99.8 cm, ILBPMB Archives.

Simple Drawings

Bo Bardi took design ethics and artistic modesty seriously. These principles guided her during the multiple activities she developed in Salvador, Bahia, which was the center of avant-garde culture in Brazil in the 1950s and 1960s. During her first decade in São Paulo, working for MASP granted her personal autonomy from her Italian foundations. Similarly, her temporary stay in the northeast of Brazil represented a moment of complete personal and professional autonomy. As she renegotiated her cultural references and affinities, she let go of strict drawing and design conventions without losing interest in themes that had been important to her all along, such as her fascination with plants and trees, her goal of technical simplification, and her concern with the quality of people's everyday lives.

In 1958, while serving as a visiting professor in Salvador, she produced a Sunday arts page for a local newspaper. The content followed that of *A, Cultura della Vita* and *Habitat*. She proposed cultural and artistic modernizations without sparing her ironic provocations, as seen in several caricatures critiquing the local elite's attachment to traditional cultural practices (Fig. 58). Moreover, between 1959 and 1964, she directed the Museum of Modern Art of Bahia, promoting not only exhibitions but also pedagogical and cultural programs and theater productions.

Bo Bardi collaborated with a lively group of romantic and revolutionary artists and intellectuals, including Martim Gonçalves, director of the Theater School, with whom she designed the stage sets—she preferred to call it scenic architecture—for two provocative plays. From this experience, she left several sketches and drawings, including a striking image for the adaptation of Castro Alves's burned down auditorium to stage Albert Camus's *Caligola*. She imagined platforms and scaffoldings surrounding the audience to eliminate the distance between the audience and the actors (Fig. 59). She brought the same simplicity, spontaneity, and openness to the improvised auditorium she created on the theater's internal ramp to house the Bahia Cinema Club. The club had been organized by supporters of Cinema Novo. From them, she learned how to visualize the customs of the northeastern hinterlands, which she represented in the leather seats evocative of horse saddles (Fig. 60).

During this period of discovery and growing autonomy, Bo Bardi also lectured about architecture to students in different programs at the University of Bahia, expressing her belief that human beings are the protagonists of space, as in theater.[31]

She praised the work of Antoni Gaudí and Frank Lloyd Wright in her talks[32] and enhanced her texts with information gleaned from discussions with Bruno Zevi about her interpretation of what organic architecture could be. She was interested in the use of vegetation and minerals and started to fill many of her architectural drawings with representations of lush, colorful plants, pebbles, and ceramic shards. She developed two house projects that materialized those experiments: the Cirell House, completed in 1958 and still standing close to her house in São Paulo, and the Chame-Chame house, completed in Salvador in 1964 and demolished in the late 1980s.

The Cirell House initiated a dramatic shift in Bo Bardi's conception of architectural design. She maintained her way of thinking about and using architectural plans, sections, and perspectives, but changed the overall language, appearance, and materiality of her work. Her plans and sections remained anchored in regular geometric figures, but they no longer represented rationalist principles. Instead, they emulated Wrightian principles such as the organization of the domestic space around a fireplace (Fig. 61) and Gaudí's natural forms, seen in her drawings for an inflorescence-like wooden staircase (Fig. 62). The Chame-Chame house began as a cubic structure, as her sketches attest, and evolved into a U-shaped volume organized around a languid staircase, "like a lizard," as Bo Bardi described in a lecture about architecture and nature delivered a few years before, "lying on rocks in the sun"[33] (Fig. 63). She gradually moved away from the debate among European architects around organic architecture and turned to Brazilian sources. She would later identify her work as "poor architecture" (or simple architecture), likely informed by her awareness of the material critique of Arte Povera and the harsh realities she saw in the depths of Brazil. She used the term *poverty* not in the economic sense, but to "express the maximum of communication and dignity while employing fewer and humbler means."[34]

Bo Bardi's drawings increasingly adhered to her pursuit of simplification in architecture and her fascination with the plain, everyday objects produced by laypeople in the northeast, whom she came to admire as authentic sources for industrial Brazilian design. In 1959, while collaborating with Martim Gonçalves, she gave life to his project for a large exhibition of popular craft to correspond with the International Art Biennial in São Paulo. The show, titled *Bahia*, was installed under the tip of the wide-spreading canopy facing the biennial pavilion and confronting the Arte Povera works displayed inside it. In a large, colorful drawing produced for the event, Bo Bardi illustrated display nooks with curtains under the

concrete slab (Fig. 64). Each space displayed objects produced by laypeople under dire survival conditions in the hinterland of the country.

The *Bahia* exhibition, conceived in increasingly polarized social conditions, announced Bo Bardi's engagement with radical cultural politics in Brazil. Four years later, in 1963, before being forced to leave the directorship of the Museum of Art of Bahia, she installed a revised version of the show and titled it *Nordeste* (Northeast). The exhibition marked the opening of the museum branch dedicated to popular art in the converted colonial Unhão Estate, which was part of her goal of creating an alternative school of design based on popular everyday objects. This experience was short-lived, but she revisited it a third time in 1968, in the exhibition *The Hand of the Brazilian People* for the opening of MASP's daring concrete building on Avenida Paulista in São Paulo. The sketches she produced for the show reproduced the logic of her previous exhibitions in simple theatrical displays. She still relied on classical frameworks such as one-point perspectives, but she started to use the economy of line that would increasingly mark her works (Fig. 65).

Bo Bardi left Salvador in 1964, following the coup d'état that treated the activities of avant-garde groups in Bahia with suspicion. She returned to São Paulo and dedicated herself to the design of the complex structure and program for the new building to house MASP, the design and construction of which lasted almost eleven years, and which she documented in drawings. Among the documents in her archives, there are a few images—most of them simple drawings in perspectival mode—that reveal her multifaceted understanding of architecture with a striking graphic quality. They represent her interest in the theatrical quality of collective cultural spaces, her concern with the balance between small- and large-scale features, her discovery of the power of exposed structures and materials, and her continued interest in organic elements.

The project to design and construct MASP's building resulted from a convoluted process. It began in 1957 during a period of great hope in Brazil, epitomized by the construction of Brasília, and ended in 1968 at the outset of the harshest period of the military regime in the country. Still, given an ordinance that required the building to maintain an open urban panorama, Bo Bardi was able to offer the city a space of freedom, as she considered it. Some of her drawings show her effort to achieve straightforward results, often highlighting how the elevated volume allowed for the creation of a covered urban open space (Fig. 66).

The terrace underneath the raised up exhibition hall was very important to her, and she produced several studies imagining its everyday use and the effect of the

large shadow it created in the open space of the city. One of those drawings, titled "Ombra della sera" (Evening shadow) and created at the end of the construction process (Fig. 67), has great theatrical presence in the contrast between the scale of the few people represented and the concrete slab, and between the darkness of the gray structure and the colorful vegetation and sunset. The drawing also has political connotations suggested by her provocative use of red—the color associated with communism at the time—and by the ciphered words of freedom inscribed on the rough concrete surface.

A few years later, Bo Bardi proposed another provocative use of the terrace to celebrate the fiftieth anniversary of the 1922 Modern Art Week, which represented a cultural watershed in Brazilian history. As her lively image shows, instead of celebrating high art, she had the popular Piolin Circus installed in the space (Fig. 68). Her choice was historically precise and artistically liberating: Piolin, a popular actor and clown, had been a symbolic reference to early modern theater in Brazil. This gesture spoke to how Bo Bardi and her husband saw no hierarchy between elite and everyday culture, and also how she imagined the dynamic and rich relationship between the museum and the city. Beneath the terrace, she imagined another theater, represented in an unusual, economic drawing showing a few white gouache washes and colored dots against black paper, representing the direct relationship between actors and the audience (Fig. 69).

Bo Bardi produced drawings of the museum to draw out the poetry of the building's stark construction process. Two of these drawings show the use of reinforced concrete in the semiburied hall. One of them, a carefully sketched and colored perspective, shows her study for waffle slabs, creating the effect of light, floating horizontal planes and wide spans, differentiated scales, and integrated uses (Fig. 70). Another drawing shows Bo Bardi's study for the two cantilevered stepped ramps that cross the space in the lower halls. This simple image colored in striking red attests to her understanding of the combined possibilities of drawing, structure, and architecture (Fig. 71).

During the building's construction, in 1964, Bo Bardi produced a large elevation to study potential enclosure systems for the elevated exhibition hall (Fig. 72). She originally wanted the galleries on both floors to be completely enclosed, with openings only along the edges of the lower level to provide natural light and ventilation to office areas. This detailed pencil drawing suggests the creation of a series of precast vertical panels in reinforced concrete, which turned out to be too heavy to assemble into floor slabs. Bo Bardi finally agreed to have the volume enclosed

with a curtain wall system, letting go of her desire to cover the outside museum walls with pebbles and plants, as she had done in the two houses she had recently completed. This powerful image confirms Bo Bardi's belief that architecture is born out of drawing.

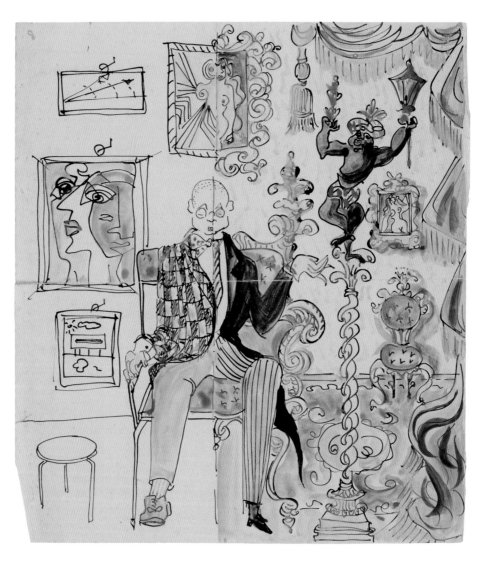

58 Lina Bo Bardi, Caricature study for *Diários de Notícias* Sunday cultural page, Salvador, BA, 1958. Felt pen and pencil on paper, 32.4 × 24.8 cm, ILBPMB Archives.

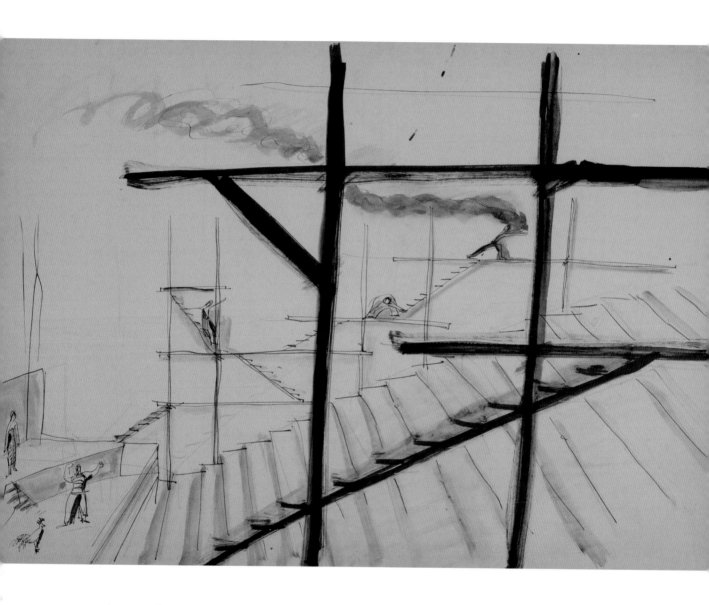

59 Lina Bo Bardi, Set design study for "Caligola" at Castro Alves Theater, Salvador, 1960. Watercolor, pencil, and India ink on card stock, 38.5 × 50.5 cm, ILBPMB Archives.

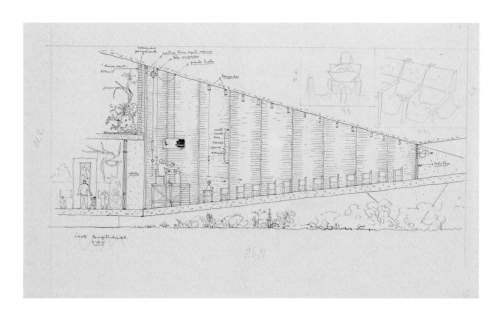

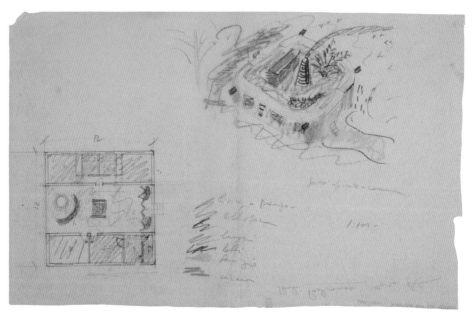

60 Lina Bo Bardi, Study for Museum of Art of Bahia, improvised auditorium on Teatro Castro Alves ramp, 1959. Pencil on paper, 21.1 × 29.7 cm, ILBPMB Archives.

61 Lina Bo Bardi, Initial study for Cirell House, plan and perspective with central fireplace, 1957. Watercolor, pencil, colored pencil, dry pastel on tracing paper, 31.7 × 50.0 cm, ILBPMB Archives.

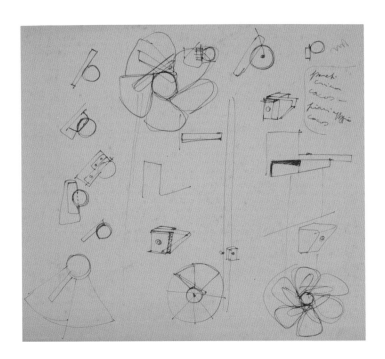

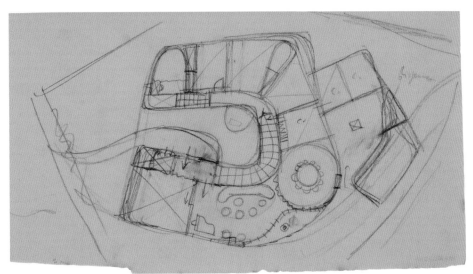

62 Lina Bo Bardi, Study for Cirell House's helicoidal staircase, construction details, 1958. India ink on paper, 24.5 × 27.5 cm, ILBPMB Archives.

63 Lina Bo Bardi, Study for Chame-Chame House, ground floor layout, 1958. Pencil on tracing paper, 19.0 × 35.1 cm, ILBPMB Archives.

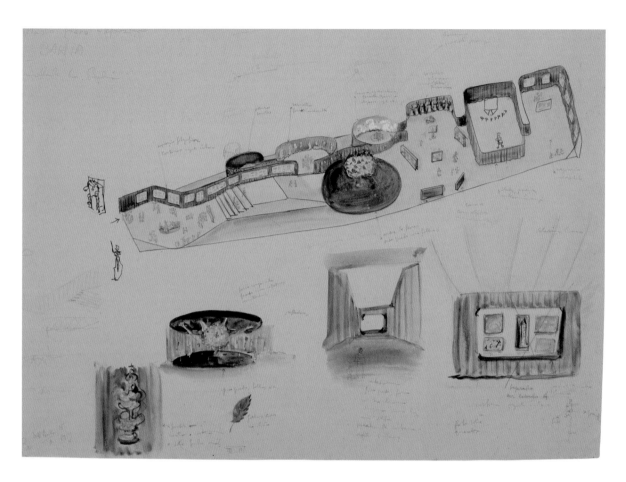

64 Lina Bo Bardi, Study for exhibition layout, *Bahia* at Ibirapuera Park, São Paulo, 1959. Watercolor, ballpoint pen, pencil, India ink, metallic paint on card stock, 50.5 × 70.3 cm, ILBPMB Archives.

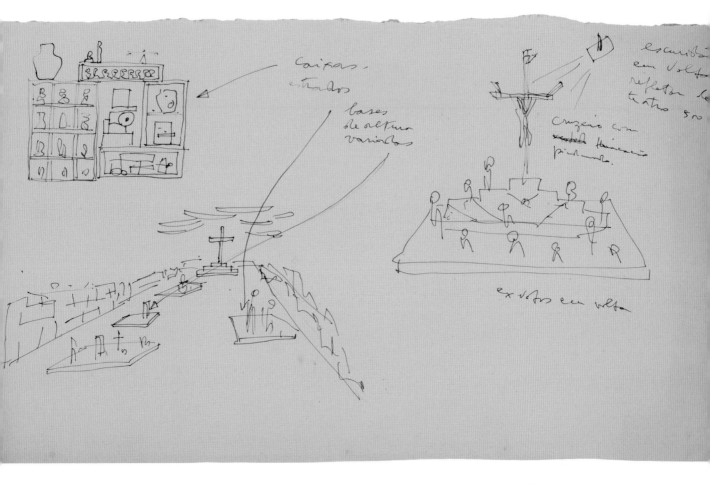

65 Lina Bo Bardi, Study for exhibition layout, *The Hand of the Brazilian People*, at the Museum of Art of São Paulo, 1968. Felt pen on card stock, 21.0 × 37.4 cm, ILBPMB Archives.

66 (*following pages*) Lina Bo Bardi, Museum of Art of São Paulo, museum and terrace, lateral perspective with plants, ca. 1964. Pencil, India ink, collage on tracing paper, 50.1 × 69.9 cm, ILBPMB Archives.

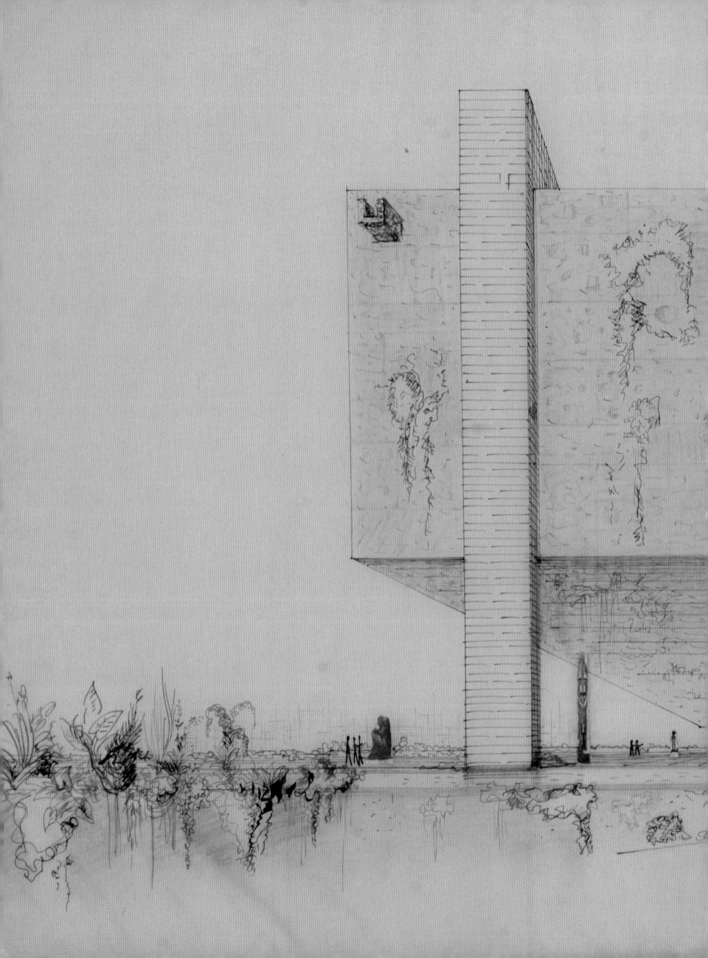

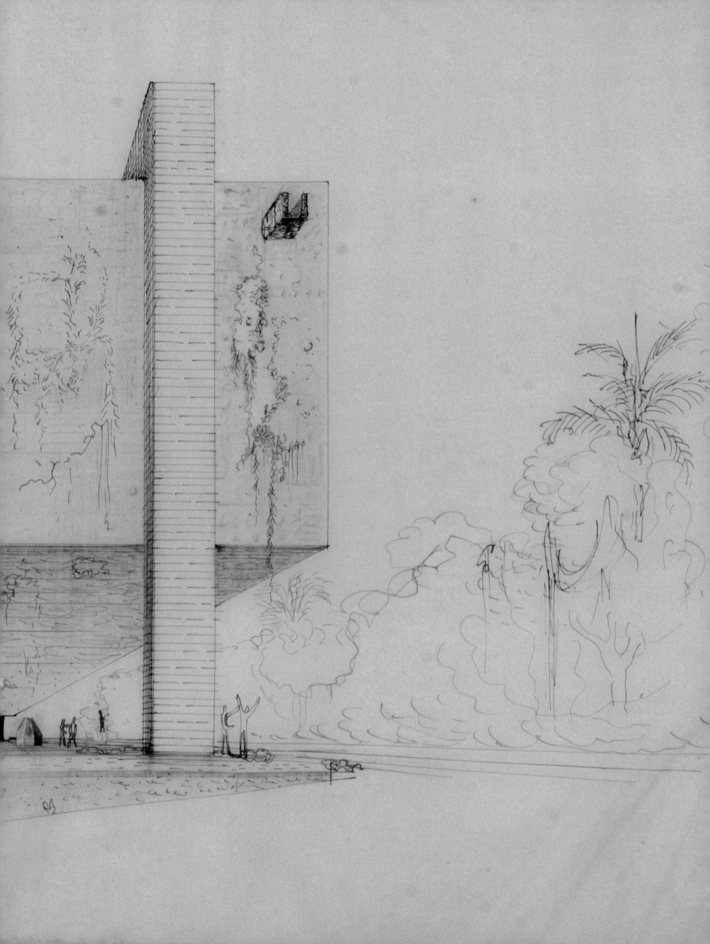

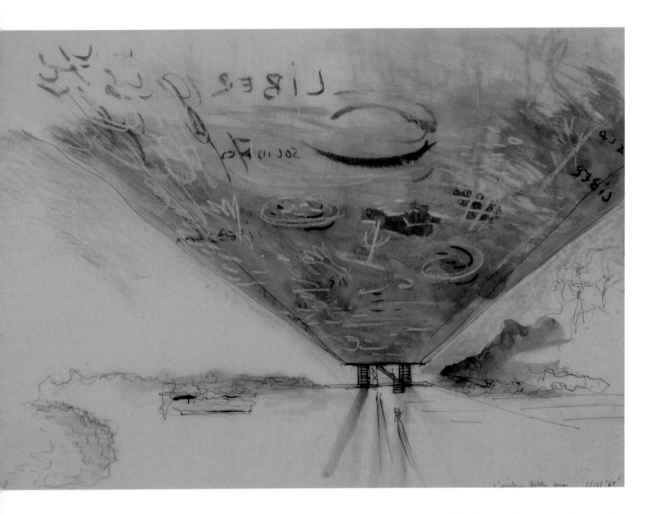

67 Lina Bo Bardi, Belvedere plaza perspective, Museum of Art of São Paulo, mid-1960s. India ink and dry pastel on tracing paper, 49.9 × 69.5 cm, ILBPMB Archives.

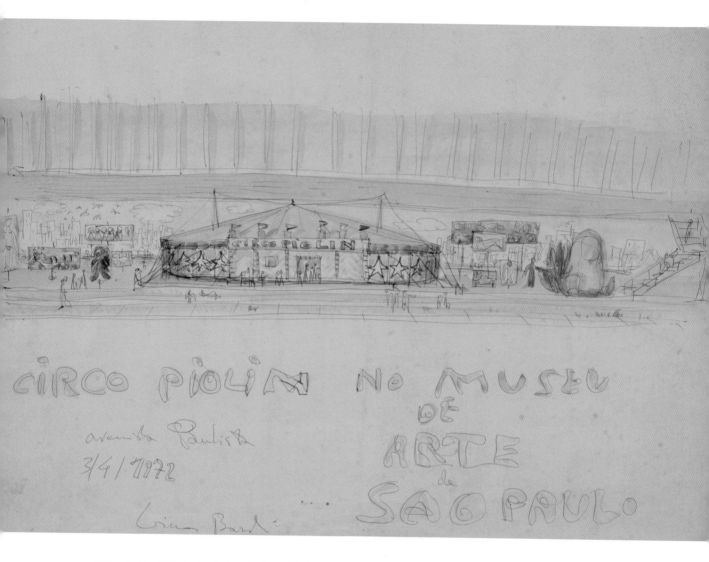

68 Lina Bo Bardi, Study for the installation of Piolin Circus under the Museum of Art of São Paulo, 1972. Watercolor, felt pen, and pencil on card stock, 32.1 × 47.0 cm, ILBPMB Archives.

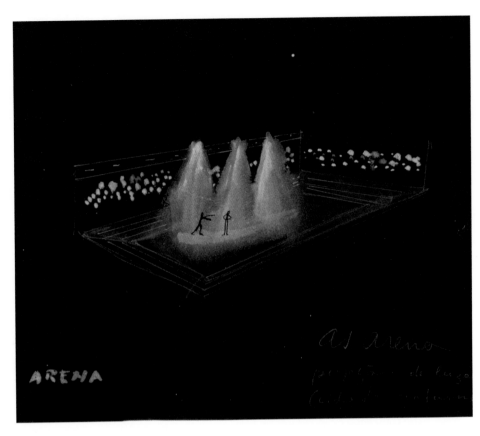

69 Lina Bo Bardi, Study for theater, Museum of Art of São Paulo, mid-1960s. Gouache and pencil on card stock, 24.4 × 30.0 cm, ILBPMB Archives.

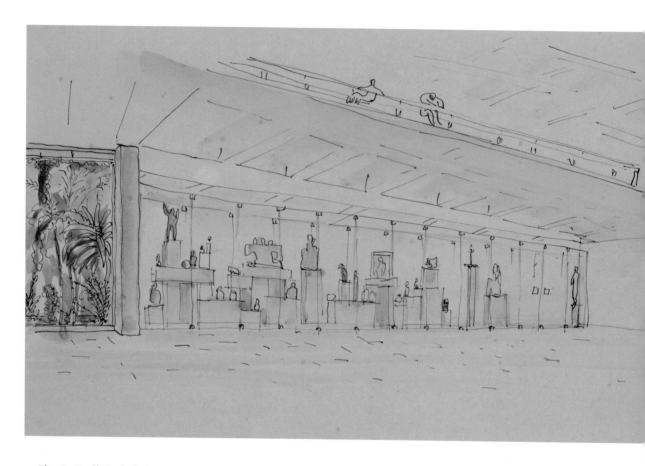

70 Lina Bo Bardi, Study for basement restaurant enclosure, Museum of Art of São Paulo, mid-1960s. Watercolor and India ink on card stock, 19.0 × 29.6 cm, ILBPMB Archives.

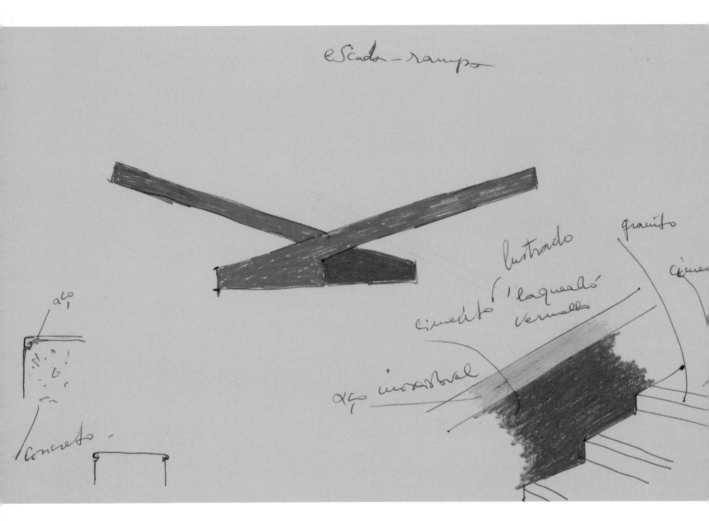

71 Lina Bo Bardi, Study for double ramp in reinforced concrete, Museum of Art of São Paulo, mid-1960s. Felt pen, ballpoint pen, pencil, and colored pencil on paper, 15.5 × 24.7 cm, ILBPMB Archives.

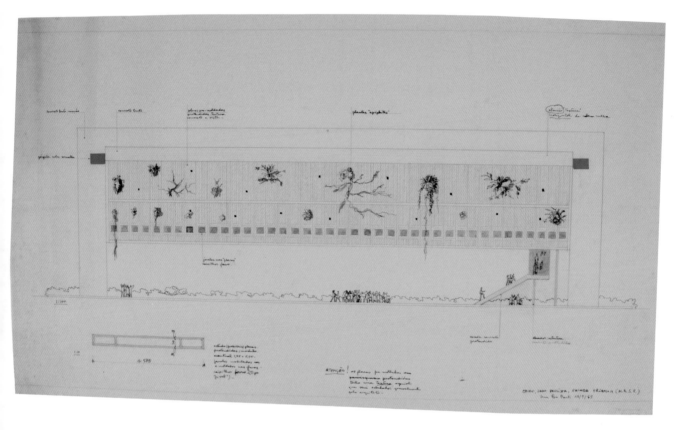

72 Lina Bo Bardi, Initial study for exhibition hall precast concrete panel enclosure system with planters, Museum of Art of São Paulo, 1966. India ink, pencil, and colored pencil on tracing paper, 56.8 × 99.7 cm, ILBPMB Archives.

Drawn to Nature

In the process of creating architecture, Bo Bardi drew and redrew certain shapes and elements. She often used green pencils and felt pens to create organic marks with fluid gestures to heighten the liveliness of the subjects she portrayed. In her drawings, she surrounded buildings with plants, and she imagined filling up cities with them. More than trying to conceal structures, as she initially envisioned for the Museum of Art of São Paulo and the smaller buildings and houses she designed in the 1960s, she developed the concept that architecture should connect to nature.

Bo Bardi was fascinated with the lush landscapes she found in Brazil. In working with Bruno Zevi on the creation of the magazine *A, Cultura della Vita* in 1946, she had become acquainted with his critique of architectural rationalism through the publication of his book *Verso un'architettura organica (Toward an Organic Architecture)* the previous year. But she did not completely agree with Zevi. After moving to Brazil, the two maintained a long-term correspondence, in which she discussed her mediatory, hybrid positions on architecture. She made her views public in a lecture in Salvador in 1958, in which she proposed to relate rationalist and organic architecture, rather than view them as separate categories. She stated, "While the organic architect rests on nature, accepting it in all of its manifestations, including its irrationality as well as its tragic and unchangeable aspects, the non-organic architect accepts nature, but with reservations about what is irrational in it."[35] "Organic architecture," as she described it to the audience, "tries to mimic nearby nature, surrendering to it without offering resistance or wishing to dominate it. It accepts nature and loves it. It derives its taste from primary and rustic materials."[36]

According to Bo Bardi, "Architecture frames nature without belonging to it."[37] To her, architecture should "welcome nature, accommodate itself to it, and try to emulate it like a living organism."[38] She strove not to imitate nature but to observe its "valid realities and to look for solutions within the boundaries of actual possibilities," while not denying abstract principles, writing, "Architecture delicately rests on nature like an object on a table, an architecture that 'observes' nature."[39]

The Cirell House, which she designed for friends and neighbors in São Paulo, was the precursor of her experimentation with naturalistic elements. She produced several drawings for different versions of the project, evoking conceptual elements she saw in publications of Wright's houses and especially features she observed

during her visit to Gaudí's Park Güell in Barcelona in 1956. She took several photographs of architectural details during that visit, fascinated by the walls covered with ceramic mosaics, pebbles, and many plants. With great care, Bo Bardi drew an elevation study for the Cirell House, translating Gaudí's wall treatment to the tropics (Fig. 73). Her attention to detail is evocative of the Catalan architect's work and also of the garden illustrations she produced during her magazine work in Milan in the previous decade.

After the completion of the Cirell House in 1958, Bo Bardi reflected on her own house, located only three hundred meters away. She concluded that she would not have made another glazed structure if she were to design her house again. She envisioned a lower addition to it and produced several drawings, including one showing an organically shaped pavilion covered with vegetation and featuring small courtyards for large trees (Fig. 74). The addition did not move beyond the paper stage, but over the years, she installed curvilinear pathways with short retaining walls covered with pebbles and ceramic shards into the steep landscape surrounding the property. She also continued to plant trees around the property, which have grown into the woodlands that now screen out the transparent house.

Bo Bardi never abandoned the green tones of her watercolor kit, pencils, and felt pens. Plants would be a constant presence in her architectural sketches and drawings after the 1960s. Among these is a colorful study she prepared for the renovation of a reptile display at the Butantã Research Institute in São Paulo, attesting to her aspiration to relate architecture and nature (Fig. 75). In the following years, she produced a series of drawings, mostly watercolor perspectives, some unidentified, for small buildings and houses in which architecture and nature interact. As in her house pavilion and study for the Roberto and Eliane residence of 1976, organic shapes and sunken spaces covered with plants tended to intermingle the buildings into the landscape and minimize their presence (Fig. 76).

Along with integrating buildings and plants, Bo Bardi also directly referenced organic forms. In her original study drawing for the external access staircase to the MASP building (Fig. 77) from the early 1960s, she mimicked the revolving shape of an inflorescence connecting the museum terrace with the upper exhibition hall with a helicoidal movement of baroque proportions. The span between beams did not allow for the construction of her staircase, but she used a similar idea to build the wooden one at the Unhão Estate in 1963.

Two decades later, she worked on three large-scale urban projects, whose key concepts made literal reference to plant elements. In 1981, she presented a

competition proposal for the renovation of the Anhangabaú Valley in downtown São Paulo. She proposed an elevated expressway with a large park underneath. In one of the ballpoint pen and watercolor study sketches, she outlined the viaduct's structure, writing, "support typology (trees)" (Fig. 78).[40] Between 1986 and 1988, she was invited to return to Salvador to develop a recovery project for the city's Pelourinho historic district, whose colonial housing and baroque monuments were in a state of disrepair or, as she called it provocatively, were the result of a "voluntary earthquake."[41] Several old buildings needed to be buttressed, and a few buildings would be used for social and cultural programs. The aim was to balance the increasing demands of tourism with the existence of a popular contingent in the area at a low cost and on a tight schedule. In association with architect João Filgueiras Lima, who had directed a low-cost prefabrication factory for the city's Department of Public Works, Bo Bardi designed a system of thin, corrugated ferro-cement panels that could serve numerous structural and layout purposes. The prefabricated panels were planned to look like the long, ribbed leaves of palm grass (*Molineria capitulata*), which she had in her garden.

Bo Bardi used this paneling system in all the adaptive-use projects in the Pelourinho district. She dedicated special attention to the design of the shell-shaped Coaty Restaurant around a large mango tree, as shown in her colorful study sketch for the project (Fig. 79). The restaurant was part of the largest complex in the area. The project included converting colonial estates into low-income work-live spaces along Misericórdia Hill, which Bo Bardi represented in a large drawing traced on mylar paper over a panoramic picture, joyfully painted with many green tones of gouache (Fig. 80).

Finally, in 1991, a few months before her death, she produced the largest drawing of her career. It depicted a long linear garden covering the walls of the administrative pavilion she had designed for the renovation of the São Paulo City Hall (Fig. 81). The project was never realized, but this spectacular image is testimony of her undying love of natural forms, of invention, of *disegno*, of drawing. Plants—small and large, alone and in groups—are staged in her illustrations. They are displayed on building surfaces and spaces. They are, like people, protagonists in the everyday life of architecture.

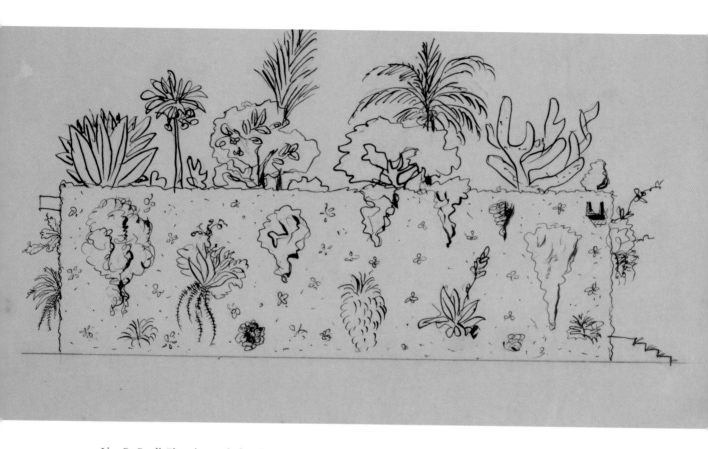

73 Lina Bo Bardi, Elevation study for Cirell House highlighting plants and organic finishes, 1958. India ink and pencil on tracing paper, 20.2 × 40.4 cm, ILBPMB Archives.

74 (*following pages*)Lina Bo Bardi, Study for pavilion and garden expansion, Glass House, no date. Felt pen, ballpoint pen, and pencil on tracing paper, 21.8 × 31.3 cm, ILBPMB Archives.

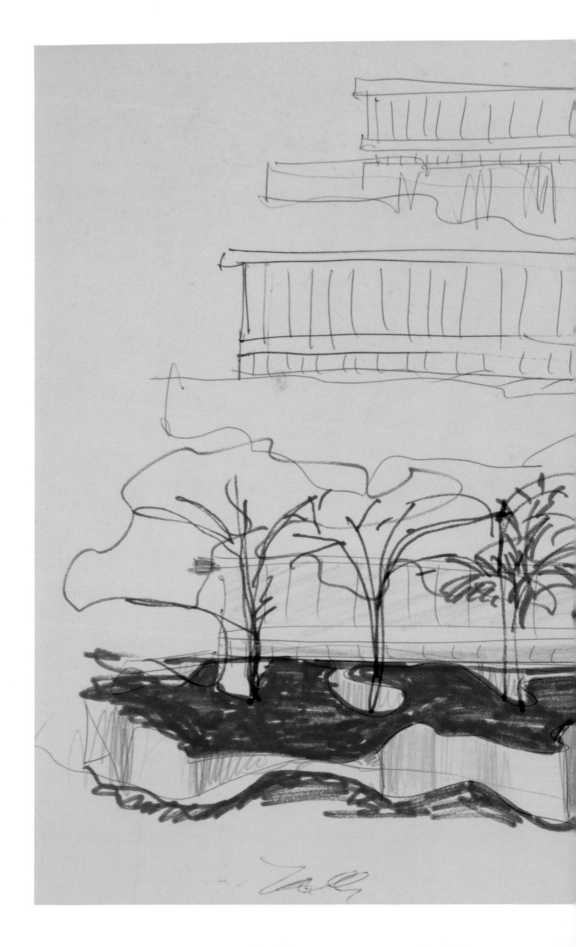

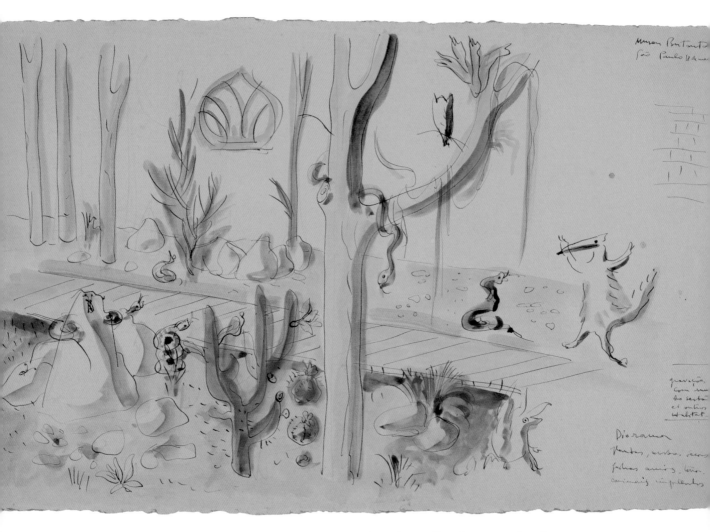

75 Lina Bo Bardi, Live reptile diorama study with native Brazilian plants, Butantã Institute Museum, São Paulo, 1964. Watercolor, India ink, and pencil on cardboard, 28.2 × 46.3 cm, ILBPMB Archives.

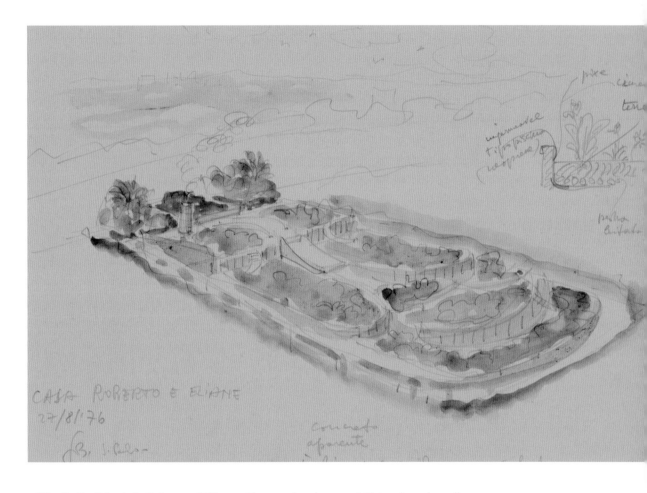

76 Lina Bo Bardi, Study for Roberto and Eliane residence and gardens, 1976. Watercolor and pencil on paper, 23.5 × 32.0 cm, ILBPMB Archives.

77 (*following page*) Lina Bo Bardi, Original study for organically shaped staircase, Museum of Art of São Paulo, study for garden house, no date. Watercolor and pencil on tracing paper, 31.7 × 18.3 cm, ILBPMB Archives.

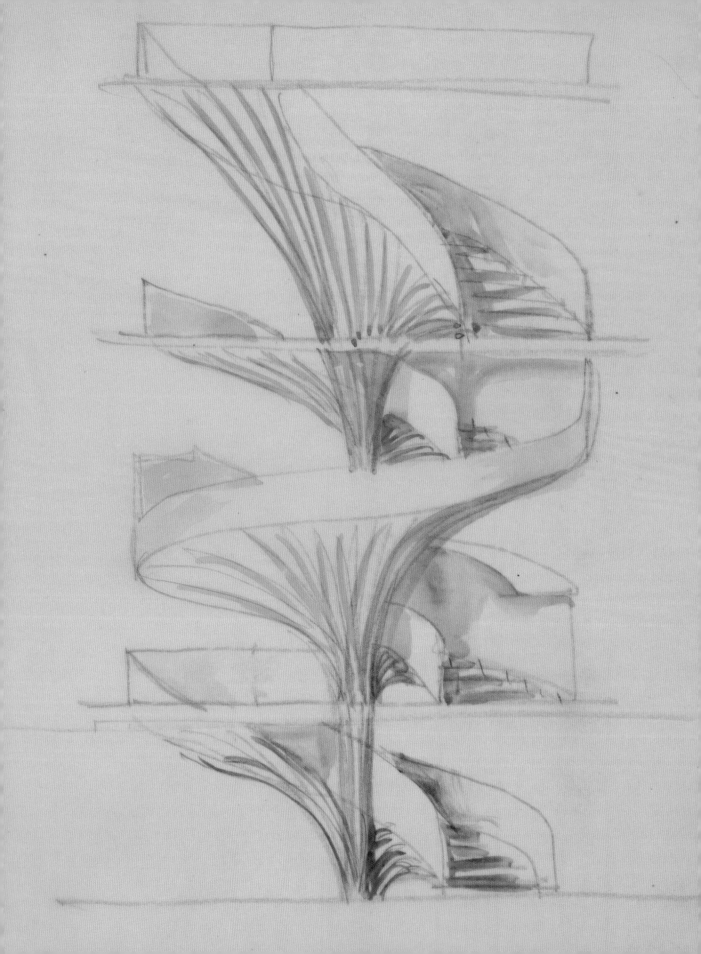

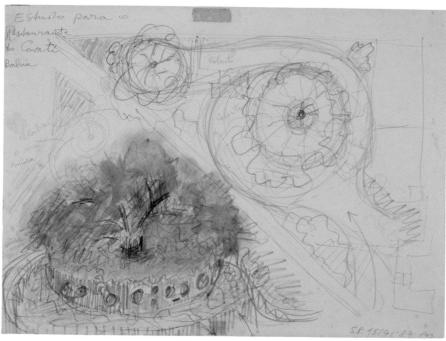

78 Lina Bo Bardi, Study for tree-shaped columns supporting expressway, Anhangabaú Valley recovery project competition, São Paulo, 1981, ILBPMB Archives.

79 Lina Bo Bardi, Study for Coaty Restaurant built around an existing mango tree with prefabricated ferro-cement panels, Pelourinho Historic District rehabilitation project, Salvador, Bahia, plan and axonometric, 1987. Watercolor, ballpoint pen, pencil, and colored pencil on paper, 29.6 × 41.1 cm, ILBPMB Archives.

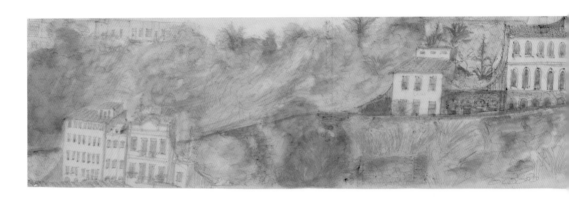

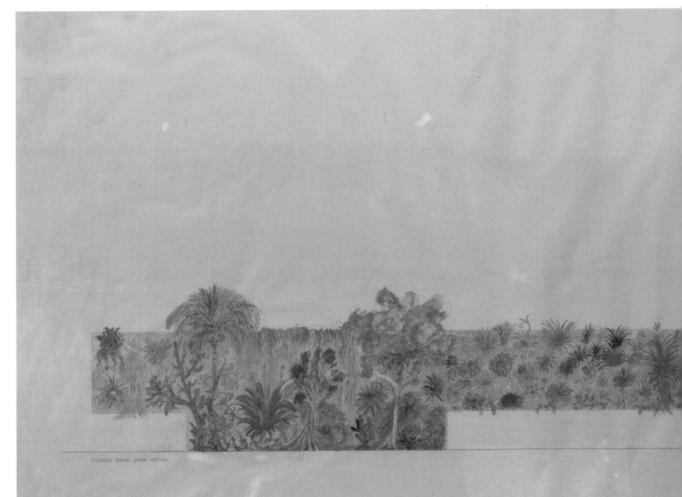

ELEVAÇÃO PAREDE JARDIM VERTICAL

ESTUDO PRELIMINAR DA "OUTRA" PAREDE (ISTO É, O JARDIM VERTICAL DE PLANTAS TROPICAIS: BROMÉLIAS, CAC

80 Lina Bo Bardi, Study for Misericórdia Hill housing and retail complex, Pelourinho Historic District rehabilitation project, Salvador, Bahia, panoramic view traced over photograph, 1987. Gouache, ballpoint pen, and pencil on Mylar paper, 29.4 × 118.0 cm, ILBPMB Archives.

81 Lina Bo Bardi, Study for vertical garden, São Paulo City Hall, D. Pedro Park, 1991. Gouache, and pencil on card stock, 70.0 × 175.0 cm, ILBPMB Archives.

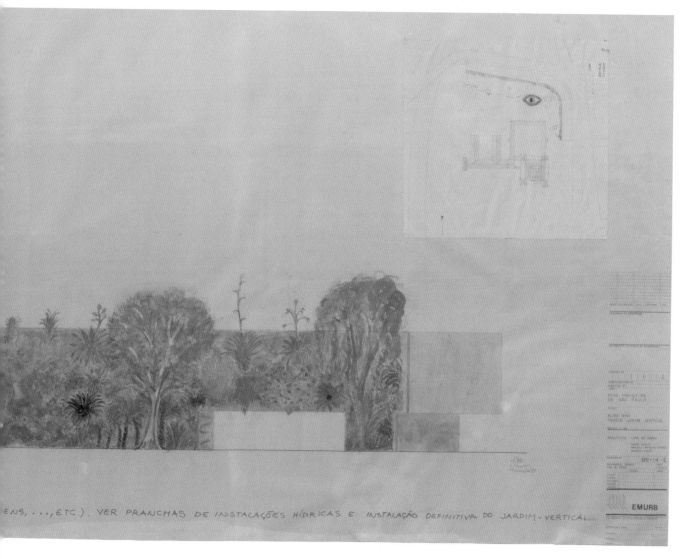

Drawing Nothing and Everything

Bo Bardi also dedicated a great deal of her drawing practice to exploring the relationship between design and the human body. Not only did she include representations of people in her drawings, she imagined the objects that she conceived as being inhabited, and embodied.

Bo Bardi's drawings often suggest a corporeal presence, even when the body is not visible, from the hand that draws a line on the paper or touches an object to the body that occupies architecture. As she demonstrated in the study drawings she made for the Frey Egydio theater chair in the late 1980s, she was concerned not only with the object's appearance, which repurposed the style of a Tuscan medieval chair, but also with the awareness of how the chair accepts the body and allows the hands to operate its folding mechanism. She also imagined this piece as part of a theater performance, providing audience members freedom to easily move it around the open stage for better visibility (Figs. 82, 83).

Her drawings remind us that everyday life is multifaceted and full of possibilities, a place for work and dreams, for individual and social existence. During her design of SESC Pompeia in the 1980s, she made a remarkable drawing reminiscent of her early Renaissance-style interior perspectives; it showed the daily uses of the snack bar at the base of the sports tower (Fig. 84). The childlike appearance of this drawing should not distract from the profound knowledge of architecture it represents. In it, Bo Bardi summarized her belief that human beings are the protagonists of space and that collective spaces, like theater stages, are places of socialization, supported by the simple but mindfully placed props.

With lively motions, she produced sketches showing that the human body is not the measure of all things. The body, in her drawings, is the place in the world through which a design object—a spoon, a necklace, a chair, a stage prop, a room, a building, a city—may be experienced. Her archives abound with examples produced throughout her career, from the study of furniture for public spaces (Fig. 85) to the conception of a theater imagined as an inviting popular circus tent (Fig. 86), and from the design of imaginative and colorful jewelry (Fig. 87) to somber theater costumes (Figs. 88, 89) and colorful everyday uniforms (Fig. 90).

The design language Bo Bardi articulated in her mature years came alive by reconciling the visual and the corporeal experience and by merging various realities and scales. The years she spent in the creation of the SESC Pompeia Sports and

Leisure Center, between 1977 and 1986, provided the opportunity for experimentation. The center—completed when she was seventy-two years old—epitomizes the high point of her career, a rare combination of architecture, theater, furniture, visual communication, and exhibition design, all represented in a profusion of drawings.

Bo Bardi left a large collection of sketches demonstrating her ability to freely associate ideas, objects, spaces, sports, leisure, and community service. These sketches range from one of her first images for the center done in 1977, proposing to transform the large factory structures into a vast landscape of multipurpose environments filled up with plants (Fig. 91), to a delicately scaled study for a sidewalk embedded with colorful Brazilian stones (Fig. 92), reminiscent of a 1947 manuscript describing her fascination with precious minerals.[42]

When she spoke of designing the SESC Pompeia facilities, she said she only added a few elements to an existing building already in use; she liked to believe she touched everything through doing almost nothing. She wanted to create something meaningful. She once stated in an interview, "I hope the sports complex will be ugly, uglier than MASP."[43] And, as her striking drawing indicates—imagining that the center would eventually be surrounded by high-rises—(Fig. 93), the complex turned ugliness into a thing of beauty.

Bo Bardi's drawings for SESC Pompeia show how she accepted its long design process as a lesson in letting go. The place she described as a citadel of freedom within a troubled city was also a place of personal liberation.[44] Her drawings returned to the simple marks she made in her childhood. However, unlike in her early drawings, their apparent imprecision was not caused by hesitation or lack of skill. The reduction in lines, imprecise textures, and intense color contrasts was the result of deliberate choices made to convey emotion and affect that only the messiness of life—instead of polished forms—can bring to architecture.

SESC Pompeia, in Bo Bardi's mind and in her drawings, was a field for human contact and conflicts, a place where she imagined serene, romantic references to nature (a pond emulating a river, a railing evoking plant life, or a sidewalk reminding one of a path in the woods) coexisting with industrial images and metaphors of war and combat (a bunker-like tower, window portals suggesting the aftermath of a cannonball barrage), all nurturing collective living and leisure as part of everyday culture.

Like the drawings of children, who at an early age spontaneously engage in

mark-making, Bo Bardi's drawings suggest a process that prefigures writing in an attempt to understand the environment around her, to experience it, and inhabit it. Her drawing for the unusual theater hall with facing bleachers (Fig. 94) is both an act of theatrical courage and a tribute to her earlier professional collaborations. Her watercolor for SESC's communication totem is evocative of a similar display she designed for MASP, with the added humor of a passing cat (Fig. 95). Her manicured drawing of food carts combines childlike joy with an exacting calculation of construction and utility (Fig. 96). Her lively sketches for library chairs reveal the resolve of a fast-thinking mind (Fig. 97). Her drawing of the setting for the opening ceremony of the sports towers, hinting at an exhibition about soccer, the favorite sport in Brazil, is indicative of her popular sensibilities (Fig. 98). Finally, the strikingly patterned and colored drawing she produced as a guideline for the painting of maypoles for an exhibition of work by volunteers shows that art is within the reach of all people (Fig. 99).

82 Lina Bo Bardi, Study for foldable and stackable chair, 1986. Watercolor and pencil on tracing paper, 22.0 × 15.8 cm, ILBPMB Archives.

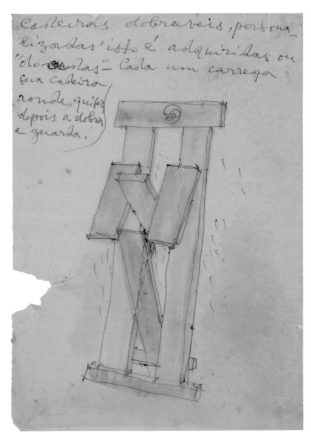

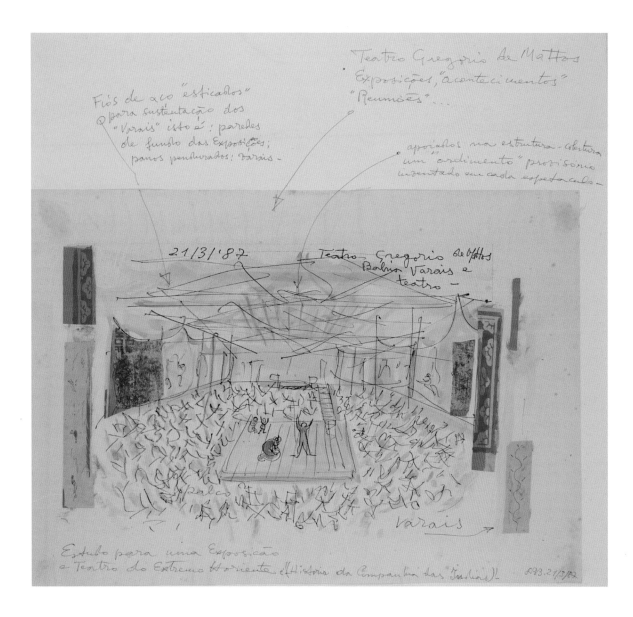

83 Lina Bo Bardi, Study for Gregório de Matos Theater and stage set based on Japanese Noh,
Barroquinha Historic District rehabilitation project, Salvador, Bahia, plan and perspectives, 1986.
Ballpoint pen and pencil on tracing paper, 43.5 × 46.0 cm, ILBPMB Archives.

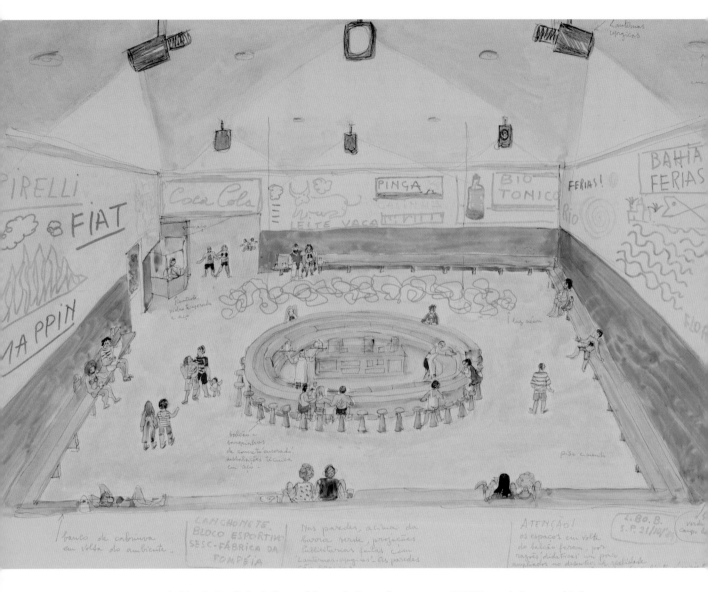

84 Lina Bo Bardi, Study for snack bar at the base of sports tower, SESC Pompeia Sports and Leisure Center, São Paulo, perspective, 1984. Watercolor, felt pen, ballpoint pen, and pencil on card stock, 50.0 × 70.0 cm, ILBPMB Archives.

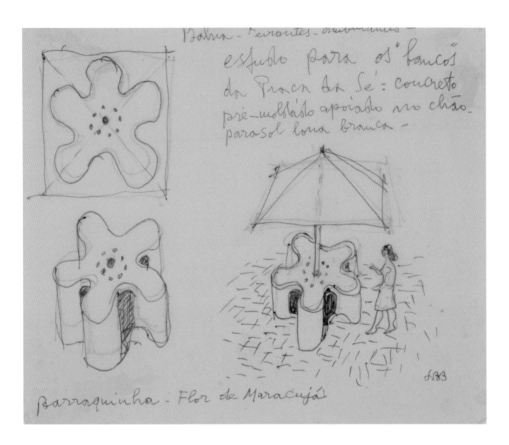

85 Lina Bo Bardi, Study for urban furniture with pyramidal umbrella and table based on flower diagram, Cathedral Square Terrace, Pelourinho Historic District rehabilitation project, Salvador, Bahia, plan and perspectives, 1986. Ballpoint pen and pencil on tracing paper, 15.9 × 19.3 cm, ILBPMB Archives.

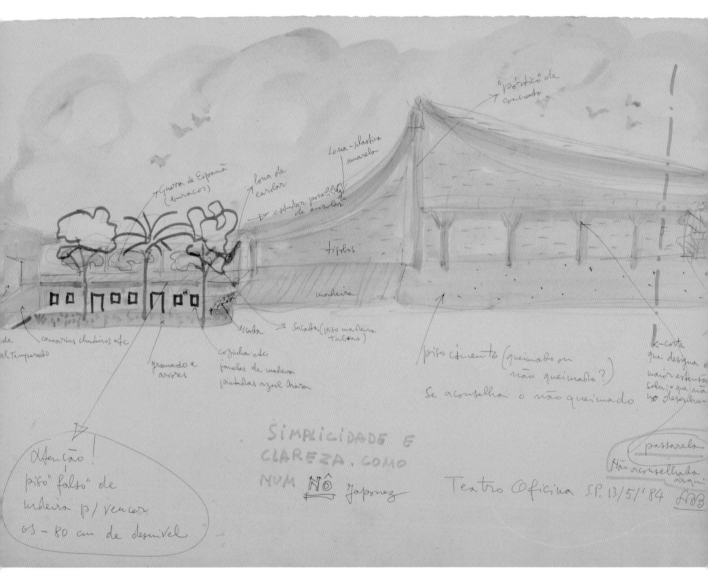

86 Lina Bo Bardi, Original study for Oficina Theater, with references to Picasso's *Guernica* and Japanese Noh theater, 1984. Watercolor, ballpoint pen, felt pen, and pencil on paper, 48.0 × 33.2 cm, ILBPMB Archives.

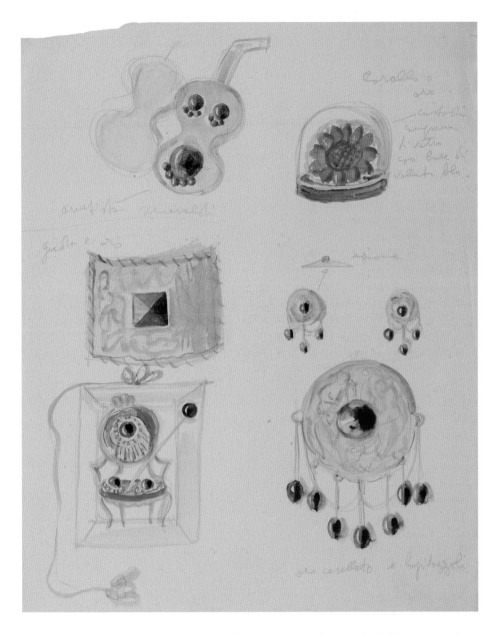

87 Lina Bo Bardi, Studies for jewelry with packaging, 1947. Watercolor, gouache, ballpoint pen, and pencil on paper, 26.9 × 20.7 cm, ILBPMB Archives.

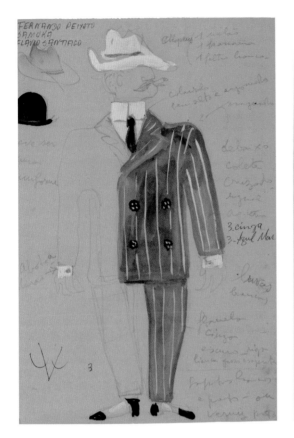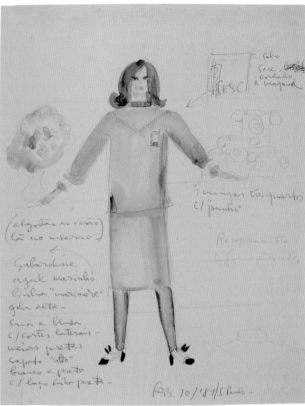

88 (*facing page*) Lina Bo Bardi, Costume study for "Caligola" by A. Camus, Castro Alves Theater (director M. Gonçalves), Salvador, 1961. Watercolor, gouache, and pencil on paper, 32.5 × 21.6 cm, ILBPMB Archives.

89 Lina Bo Bardi, Costume study for "In the Jungle of Cities" by B. Brecht, Oficina Theater (director J. M. Correa), São Paulo, 1969. Felt pen, ballpoint pen, gouache, and pencil on newsprint paper, 31.3 × 21.5 cm, ILBPMB Archives.

90 Lina Bo Bardi, Uniform study for SESC Pompeia Sports and Leisure Center associates, 1981. Felt pen, watercolor, and pencil on paper, 28.0 × 22.0 cm, ILBPMB Archives.

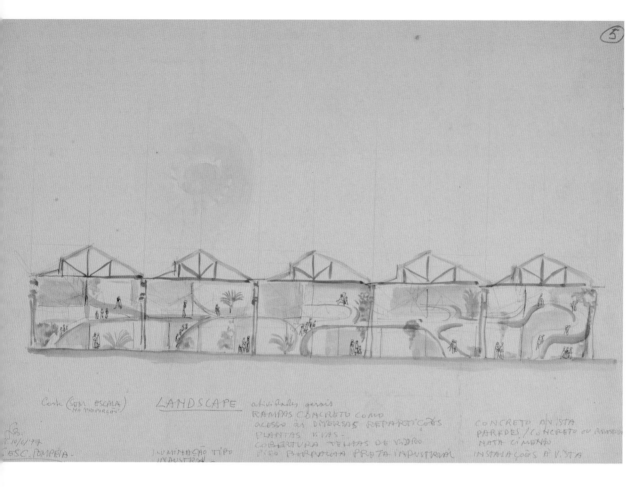

91 Lina Bo Bardi, "Landscape," preliminary study for factory conversion. SESC Pompeia Sports and Leisure Center, 1977. Watercolor, felt pen, ballpoint pen, and pencil on card stock, 38.7 × 57.5 cm, ILBPMB Archives.

92 (*facing page*)Lina Bo Bardi, Preliminary study for water channel coverage and walkway, SESC Pompeia Sports and Leisure Center, 1983. Watercolor, felt pen, ballpoint pen, and India ink on paper, 33.0 × 21.6 cm, ILBPMB Archives.

pedras semi preciosas
Brasileiras

lages concreto c/
marmores e pedras
Brasileiras (algumas,
[pequenas,] semi-preciosas

juntos madeira
de lei.

grande

as placas moveis
devem corresponder
às atuais
aberturas de inspeção

placa movel
para inspeção
do corrego
Aguas Pretas

gramado

S. Paulo maio '85

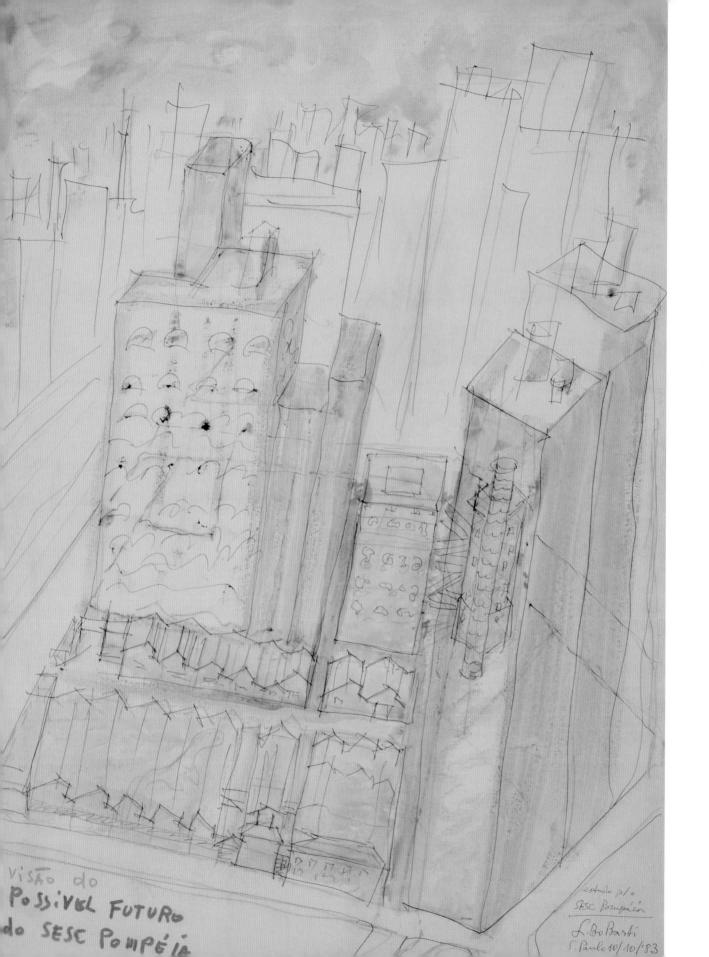

VISÃO DO
POSSIVEL FUTURO
do SESC POMPÉIA

estudo p/o
SESC Pompéia

L. BoBasti
S Paulo 10/10/'83

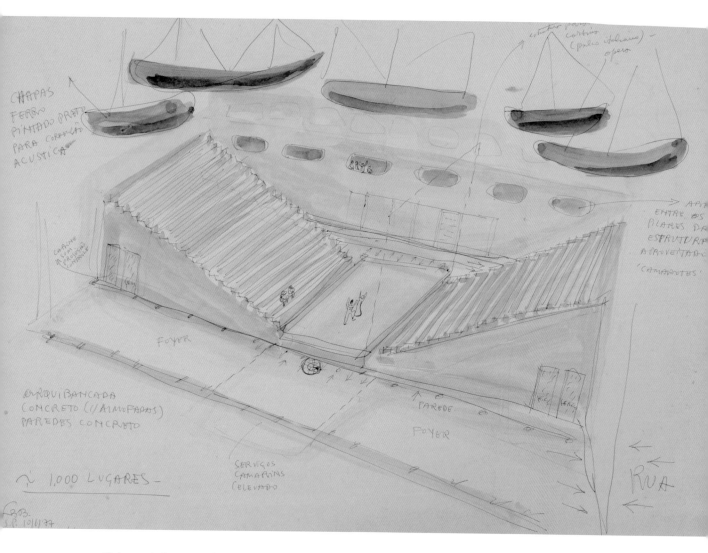

The drawing contains the following handwritten annotations:

CHAPAS FERRO PINTADO PRETO PARA CORREÇÃO ACÚSTICA

ARQUIBANCADA CONCRETO (//ALMOFADAS) PAREDES CONCRETO

~ 1.000 LUGARES

FOYER

PAREDE FOYER

SERVIÇOS CAMARINS (ELEVADO)

RUA

93 (*facing page*) Lina Bo Bardi, Drawing predicting the growth of residential towers around SESC Pompeia Sports and Leisure Center, 1983. Watercolor, pencil, and India ink on card stock, 50.0 × 35.2 cm, ILBPMB Archives.

94 Lina Bo Bardi, Study for theater in old factory shed, SESC Pompeia Sports and Leisure Center, 1977. Watercolor, felt pen, ballpoint pen, and pencil on card stock, 38.7 × 57.5 cm, ILBPMB Archives.

TOTEM SINALIZADOR

ATELIERS

ATIVIDADES GERAIS

VIDEOS

PROIBIDA ENTRADA CARROS

EXPOSIÇÃO RESTAURANTE

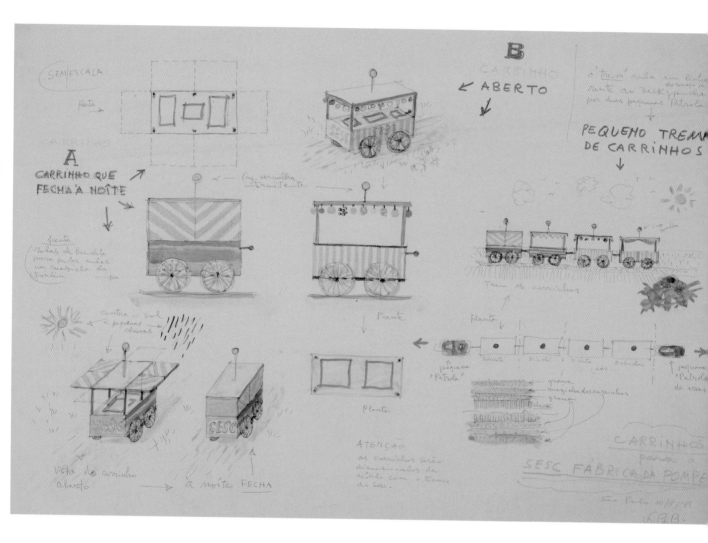

95 (*facing page*) Lina Bo Bardi, Original study for visual communication totem, SESC Pompeia Sports and Leisure Center, 1982. Watercolor, felt pen, ballpoint pen, and India ink on paper, 49.3 × 35.0 cm, ILBPMB Archives.

96 Lina Bo Bardi, Study for food carts, SESC Pompeia Sports and Leisure Center, 1982. Watercolor, felt pen, ballpoint pen, and colored pencil on card stock, 50.0 × 70.0 cm, ILBPMB Archives.

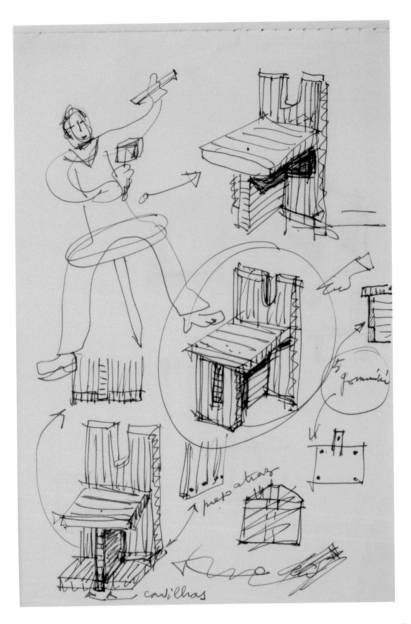

97 Lina Bo Bardi, Study for library chair, SESC Pompeia Sports and Leisure Center, no date. Ballpoint pen on paper, 21.0 × 14.3 cm, ILBPMB Archives.

98 (*facing page*) Lina Bo Bardi, Study for sports towers opening ceremony, SESC Pompeia Sports and Leisure Center, 1985. Watercolor, felt pen, ballpoint pen, and colored pencil on card stock, 69.5 × 49.7 cm, ILBPMB Archives.

99 (*following pages*) Lina Bo Bardi, Study for hand-painted maypoles for "Caipiras, Capiaus: Pau-a-pique" (Rural everyday life) exhibition, SESC Pompeia Sports and Leisure Center, 1984. Gouache, felt pen, ballpoint pen, and colored pencil on card stock, 21.5 × 31.5 cm, ILBPMB Archives.

Inauguração: Bloco
Esportivo Pompéia -
31 de Janeiro de 1985 — maio '85

Exposição
¡
Futebol – Futebol !

acompanhando no Sesc Fábrica o
irmãozinho esportivo
* ⌐ comentário Musical – AS GRANDES
MARCHAS, MUSICAS e MUSIQUINHAS DO F. MoBr

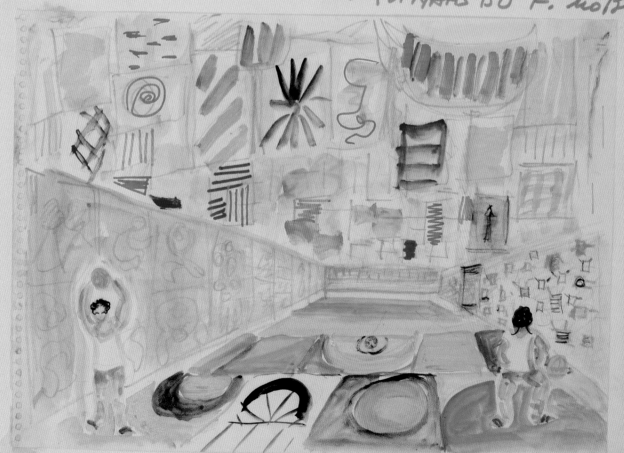

Cobra Caminosa

liso
Violeta

liso
Verde

LBB.
SP. 6/ '84

SESC

FÁBRICA DA POMPEIA

Epilogue

The woman who once said she did not want to become a painter of flowers did like to draw plants. As Bo Bardi renovated the old factory to house SESC Pompeia and its iconic concrete blocks, she included numerous organic references in her work. She illustrated a poster for the leisure center with such allusions, summarizing her personal disposition and design approach (Fig. 100).

On the left side of the page, she made a drawing of the slender tower designed for the sports facilities, cast with irregular rings in the raw concrete. She drew dozens of small flowers emerging from the top of the tower, employing circular gestures that mirror those in her childhood drawings. A few isolated flowers appear lower on the page, suggesting a slow cascading movement as they float, resisting gravity.

Bo Bardi produced a series of over thirty small sketches to conceive the layout and typography for the logo for SESC Pompeia. Her initial sketch represented the factory's sheds, but she soon developed a floral concept with several variations, fine-tuning the image's proportions and visual relationships to give the impression of spontaneity. Although Bo Bardi liked to say she had forsaken the conventions of her classical arts education, this example is reminiscent of her able *sprezzatura*, a Renaissance rule of studied nonchalance, gracefulness concealing the effort that goes into looking elegant.[45]

Her logo for SESC Pompeia projects the casual, optimistic sense of grace and liveliness found everywhere in the center's facilities. The tall cylinder in her project simultaneously suggests and denies the image of a traditional industrial chimney, holding water, one of life's most valuable natural assets, instead of soot. And the smokestack in her picture delights viewers with its surrealistic charm: instead of offering fumes to the city and to people, it showers them with white flowers.

Lina Bo Bardi culled images from the many worlds around her and created a language that let go of conventions. She strived to find meaning in the contingencies of life and offered her work as a generous, loving gesture to those in its presence.

100 Lina Bo Bardi, Logo illustration, SESC Pompeia Sports and Leisure Center, no date. Gouache, felt pen, pencil, and collaged photocopy on card stock, 67.0 × 44.8 cm, ILBPMB Archives.

Acknowledgments

I am a scholar, designer, and artist who has studied the life and work of architect Lina Bo Bardi for almost two decades, and it has been a special pleasure to write this book to accompany the exhibition I curated for the Fundació Joan Miró in Barcelona in the spring of 2019. Like Lina Bo Bardi and Joan Miró, I love drawings and I love drawing.

I am deeply grateful to Michelle Komie, enthusiastic editor of architecture and art at Princeton University Press, who suggested the topic for this book and supported this project. I am equally grateful to Martina Millà Bernad and Marko Daniel, head of programming and projects and director at the Fundació Joan Miró, respectively, who invited me to organize an exhibition about Lina Bo Bardi and immediately embraced the idea of focusing on the architect's drawings. Their generosity, knowledge, and efforts allowed for a meaningful collaboration among dedicated professionals on three different continents. I sincerely appreciate the work of Magda Anglès, the Foundation's publication coordinator. She and her team dedicated themselves to making the material in this volume available in Catalan and Spanish.

Neither this book nor the exhibition would be possible without the careful work of the staff of the Instituto Bardi / Casa de Vidro (originally titled Instituto Lina Bo e Pietro Maria Bardi) that houses and preserves, in São Paulo, Brazil, the largest collection of drawings and documents produced by Bo Bardi. Since the early 2000s, they have thoughtfully supported my long-standing research and publications about the architect. I am especially grateful to Anna Carboncini and Carolina Tatani, who attentively coordinated the work of selecting and providing pieces for publication and display.

The timely production of this book is due to the diligent editorial collaboration between the teams coordinated by Michelle Komie at Princeton University Press in the United States and Magda Anglès at the Fundació Joan Miró in Spain. Dawn Hall provided valuable editorial suggestions, and Ken Botnick sensitively brought Bo Bardi's drawings to light in this beautiful volume.

This has been a collaboration of great delight led by individuals with a shared interest in the work of this unique designer and public intellectual. The result is reality turned into a dream. May the reader be drawn by Lina Bo Bardi's marks, lines, and colors.

Notes

1 Lina Bo Bardi, "Para Pietro Lina," hand-drawn card, February 18 and 21, 1990, ILBPMB Archives.

2 Lina Bo Bardi, handwritten note on Michel Foucault, circa 1982, ILBPMB Archives.

3 Most of the drawings that Lina Bo Bardi produced are preserved in her personal archives at the Instituto Lina Bo e Pietro Maria Bardi (ILBPMB) in São Paulo, Brazil, and are available in digital form online at http://www.institutobardi.com.br.

4 Lina Bo Bardi, *Contribuição propedêutica ao ensino da teoria da arquitetura* (São Paulo: Habitat, 1957); republished in 2002 by the Instituto Lina Bo e Pietro Maria Bardi, p. 63. Piero della Francesca, *De prospectiva pingendi* (Florence: N. Fasola, 1942), 63.

5 One example of this exchange is his repainting of an urban scene Lina Bo Bardi captured in a watercolor shortly after her arrival in Rio de Janeiro in 1946, which she mailed and dedicated "to daddy." His reproduction was included in the solo exhibition she curated at the Museum of Art of São Paulo in 1950. "Enrico Bo," *Habitat*, no. 7 (1952): 37.

6 Bo Bardi, *Contribuição propedêutica ao ensino da teoria da arquitetura*, 64.

7 Graziella Bo Valentinetti, "Una sorella molto 'speciale,'" in Lina Bo Bardi, Architetto (Venice: DPA, Marsilio), 2004, 11.

8 Victoria De Grazia, Le donne nel regime fascista (Venice: Marsilio, 1993).

9 Francesco Tentori, "Una lettera da São Paulo," interview with Lina Bo Bardi in Quattro Architetti Brasiliani e un Uomo Eccezionale (Venice: IUAV, 1995), 22.

10 Lina Bo Bardi, handwritten notes to journalist Luiz Carta, circa 1989, ILBPMB Archives.

11 Lina Bo Bardi, Curriculum Vitae, typewritten document, p. 2, ILBPMB Archives.

12 Carlo Pagani, letter to Lina Bo Bardi, May 8, 1943, ILBPMB Archives.

13 Lina Bo Bardi, Curriculum Vitae, typewritten document presented to apply for tenure at the University of São Paulo School of Architecture in 1957, n.p. ILBPMB Archives.

14 Interview with Lina Bo Bardi by Fábio Malavoglia, Centro Cultural São Paulo, transcription of tape 1, side B, circa 1989, ILBPMB Archives.

15 Francesco Tentori, "Una lettera da São Paulo," in Quattro architetti brasiliani (Venice: IUAV, 1995), 21.

16 Bo Bardi, Curriculum Vitae, n.p.

17 Lina Bo Bardi in taped testimony, in Aurélio Michiles and Isa Grinspum Ferraz, Lina Bo Bardi, video (São Paulo: Instituto Lina Bo e Pietro Maria Bardi, 1993).

18 Lina Bo Bardi in taped testimony, in Michiles and Grinspum Ferraz, Lina Bo Bardi.

19 Interview with Lina Bo Bardi by Fábio Malavoglia, Centro Cultural São Paulo, transcription of tape 1, side B, circa 1989, p. 3, ILBPMB Archives.

20 Interview with Lina Bo Bardi by Fábio Malavoglia.

21 Lina Bo Bardi, "Bela Criança," *Habitat*, no. 2 (January–March 1951): 3.

22 Interview with Lina Bo Bardi by Fábio Malavoglia.

23 Lina Bo Bardi in taped testimony, in Michiles and Grinspum Ferraz, Lina Bo Bardi.

24 Bo Bardi, Contribuição propedêutica ao ensino da teoria da arquitetura, 63.

25 Bo Bardi, Contribuição propedêutica ao ensino da teoria da arquitetura, 64.

26 Bo Bardi, Contribuição propedêutica ao ensino da teoria da arquitetura, 64.

27 Bo Bardi, Contribuição propedêutica ao ensino da teoria da arquitetura, 64.

28 Bo Bardi, Contribuição propedêutica ao ensino da teoria da arquitetura, 64.

29 Bo Bardi, Contribuição propedêutica ao ensino da teoria da arquitetura, 65.

30 Bo Bardi, Contribuição propedêutica ao ensino da teoria da arquitetura, 65.

31 Lina Bo Bardi, "Arquitetura e Movimento," lecture notes, 1958, ILBPMB Archives.

32 Lina Bo Bardi, handwritten lecture notes, "Arquitetura e natureza ou natureza e arquitetura?" Salvador, September 27, 1958, ILBPMB Archives, 3.

33 Lina Bo Bardi, handwritten lecture notes, "Arquitetura e natureza ou natureza e arquitetura?" 4.

34 Lina Bo Bardi, handwritten notes on SESC Pompeia, circa 1986, ILBPMB Archives.

35 Lina Bo Bardi, handwritten lecture notes, "Arquitetura e natureza ou natureza e arquitetura?" Salvador: September 27, 1958, ILBPMB Archives, 2.

36 Lina Bo Bardi, handwritten lecture notes, 2–3.

37 Lina Bo Bardi, handwritten lecture notes, 3.

38 Lina Bo Bardi, handwritten lecture notes, 2–3.

39 Bo Bardi, Contribuição propedêutica ao ensino da teoria da arquitetura, 62–63.

40 Anhangabaú Valley competition sketch, tubular structure, 1981, ILBPMB Archives.

41 Roberto Pinho, interview in Juliano Pereira Trindade, A ação de Lina Bo Bardi na Bahia e no Nordeste (1958–1964) (São Carlos: EESC-Universidade de São Paulo, 2001), 242.

42 Lina Bo Bardi, "Stones against Diamonds," manuscript, 1947, ILBPMB Archives, published in Marcelo Ferraz, Lina Bo Bardi (São Paulo: Instituto Lina Bo e Pietro Maria Bardi, 1993), 37.

43 Frederico Morais, Lina Bo Bardi, O Estado de São Paulo, April 28, 1984, ILBPMB Archives.

44 Lina Bo Bardi, notes for interview in Casa Vogue, no. 6, São Paulo, 1986, ILBPMB Archives.

45 Baldassare Castiglione, The Book of the Courtier (New York: Dover, 2003).

Index